PAINTING
Boats and Harbors

HARRY R. BALLINGER

Dover Publications, Inc.
Mineola, New York

Planet Friendly Publishing
 ✔ Made in the United States
 ✔ Printed on Recycled Paper
Learn more at www.greenedition.org

At Dover Publications we're committed to producing books in an earth-friendly manner and to helping our customers make greener choices.

Manufacturing books in the United States ensures compliance with strict environmental laws and eliminates the need for international freight shipping, a major contributor to global air pollution.

And printing on recycled paper helps minimize our consumption of trees, water and fossil fuels. The text of *Painting Boats and Harbors* was printed on paper made with 30% post-consumer waste, and the cover was printed on paper made with 10% post-consumer waste. According to Environmental Defense's Paper Calculator, by using this innovative paper instead of conventional papers, we achieved the following environmental benefits:

Trees Saved: 13 • Air Emissions Eliminated: 1,081 pounds
Water Saved: 4,457 gallons • Solid Waste Eliminated: 577 pounds

For more information on our environmental practices, please visit us online at www.doverpublications.com/green

Bibliographical Note

This Dover edition, first published in 2008, is a republication of the work originally published by Watson-Guptill Publications, New York, in 1959. The original color plates have been gathered together as an eight-page color insert between pp. 32 and 33. These plates also appear in black and white in their original positions in the book.

Library of Congress Cataloging-in-Publication Data

Ballinger, Harry Russell, 1892–1993.
 Painting boats and harbors / Harry R. Ballinger.
 p. cm.
 Originally published: New York : Watson-Guptill Publications, 1959.
 Includes index.
 ISBN-13: 978-0-486-46428-2
 ISBN-10: 0-486-46428-8
 1. Marine painting—Technique. I. Title.

ND1370.B28 2008
751.45'437—dc22

 2008016074

Manufactured in the United States of America
Dover Publications, Inc., 31 East 2nd Street, Mineola, N.Y. 11501

For our good friends:

MARY GRAY *and* RALPH HARVEY

who also love the sea

Contents

Introduction

EVERY TIME I SEE A HARBOR SCENE painted by an inexperienced artist, in which the boats look like floating bungalows and the sea gulls resemble mosquitoes or fat pigeons, I feel upset and wish that I could do something to help him do a more professional job.

Harbor scenes are fascinating to paint and make the finest kind of pictures if they are done well. Most people, when painting a harbor, will settle for a boat or two moored to what is supposed to be a wharf, with a few misshapen figures sometimes thrown in for good measure. They should be able to do much better than that.

When one is painting a harbor it is a good plan to show some of the action that is taking place. Boats should occasionally be painted under way — either coming in to dock or starting out to sea. It is also fun to try to paint the scene in different light effects and moods.

Boats and harbors are probably more difficult to paint than surf scenes; it is much harder to draw a boat than a wave. After all, moving water isn't too difficult to paint if you understand the principles that govern its movement, but boats have to be drawn correctly in order to look convincing. The artist has to understand their general contours and has to make them look as though they were *in* the water, not just sitting on top of it.

Last year, when I wrote *Painting Surf and Sea*,* I felt that it should have a companion volume, for I think that most of us who love the sea also have a deep affection for boats and harbors. In any event, marine painters should be able to paint boats as readily as they portray surf and open sea for they are all marine subjects and equally interesting.

It isn't easy to paint boats. There is a lot of difficult drawing involved. Also, an artist painting around a harbor is liable to run into all kinds of complications before he can finish his picture. Boats have an unpleasant habit of going to sea the minute you start painting them. It helps, therefore, to know as much as possible about them in order to be able to sketch them in rapidly before they get away from you. Then, too, the tide is constantly rising or falling. A boat that

* Available as a Dover reprint (0-486-46427-X).

looms up majestically at a wharf when you start to paint it sometimes ends up down in a hollow before you can finish it — or else it completely disappears behind the wharf. There are other hazards often encountered when painting harbors, such as the bystanders who like to watch you paint and the fishermen's big cars that take up so much of the foreground that it is difficult to see the boats!

In order to help the painter through these initial difficulties, I have tried to include in this book all the information that I could. It is written in simple, non-technical language that can easily be understood by the amateur artist or student. I have also included a great many tips on picturemaking that I have picked up the hard way, after many years of painting on the waterfront.

In my own work, I have always preferred the sturdy picturesqueness of the plebeian working boats to the yachts or pleasure craft, which seem a little too effeminate to suit me. Most of this book, therefore, deals with fishing boats, draggers, lobster boats and the more colorful types of sailing and cargo-carrying vessels which, while beat-up in appearance, are much more interesting to paint. In addition to picturing and talking about some of the more familiar types of vessels, I have touched on ships at sea and some wrecks along the coast.

In order to make this a comprehensive book on marine painting, I have had to repeat some of the information on art materials and equipment, composition and painting techniques that appears in my first book, *Painting Surf and Sea*. I hope that readers forgive me for restating a number of these ideas. I do so only because I consider this information vitally important for any kind of successful painting.

Ever since I was a youngster I have preferred books that were full of pictures — in fact, the more the merrier. As you will see, this book has been profusely illustrated for the benefit of those kindred souls who would rather look at pictures than read the text. Even if you dislike wading through pages of print, you can still learn a lot about painting boats and harbors simply by studying the pictures.

Here, then, is a book that contains all the information that has helped me with my own boat and harbor scenes and that will, I hope, be of some value to you. If any of the ideas contained in this book make it easier for you to do a more professional job, I shall be very happy.

HARRY R. BALLINGER
New Hartford, Connecticut

1: *Oil Painting Equipment*

ALTHOUGH I HAVE PAINTED a great many watercolors in my life, I still consider oils a much easier and more flexible medium in which to work. The instructions in this book will be based on painting in oil, and I will try to give you all the information at my disposal to help you handle this medium in a professional manner.

Some artists and many students think that they have to paint in watercolors for years before they acquire sufficient skill to work in oils. This assumption has always seemed absurd to me, for there is no medium as easy to work in as oil. You can make changes and repaint the picture with the greatest of ease if you are using oil, while in watercolor you are in trouble if a single wash goes wrong.

Painting in oil isn't like drawing with a pencil. Your brush strokes should be broad and strong, so accustom yourself to working on a fairly large scale from the start.

For the benefit of those who have had no previous experience with oil painting, I will list the necessary equipment for out-of-door painting.

You will need a sketchbox to carry your brushes and paints. A wooden box 12 x 16 inches is a good size, although you can use a 16 x 20 inch box if you prefer a more generous one. Sketchboxes are usually made of wood, though some people prefer those of aluminum because of their light weight. A smaller sketchbox is easier to carry, but I think one does better with a fairly generous size.

A palette comes with the sketchbox, though some artists like to use a paper palette with disposable sheets. If you use a wooden palette it is a good idea to rub a little linseed oil on it, when new, in order to give it a smoother and less porous surface on which to mix your paint.

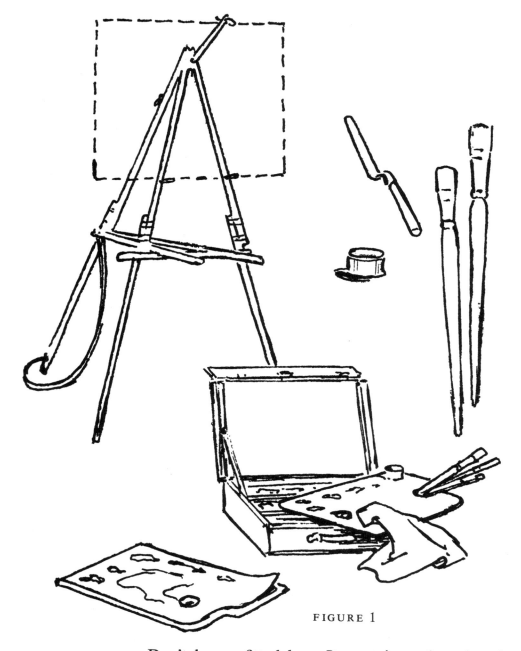

FIGURE 1

Don't buy a fitted box. It contains a lot of useless colors and is much too expensive.

You will want a good, solid sketching easel of either wood or aluminum. My favorite is the Anderson easel, now being manufactured by Edith Anderson Miller in Cincinnati, Ohio. It has a shelflike arrangement below the canvas on which to rest the sketchbox and palette. This easel folds up compactly and has a shoulder strap for carrying.

12

It is a great help when you are wandering around the docks with a sketchbox in one hand and a couple of canvases in the other. Some of the aluminum easels have a similar arrangement. If the easel hasn't a place for a palette, you can nail three stretcher sticks together to fit down over the easel and give you a platform for it.

I never paint while holding the palette in my left hand. It is uncomfortable and, moreover, you need your left hand to hold extra brushes or a paint rag.

I recommend at least six brushes, ranging from a quarter of an inch to an inch in width, and prefer bristle brushes to sable, because you are liable to get your work too polished with sable brushes. These brushes should be flat with a square end, either the type called *brights* with short bristles or those with slightly longer bristles called *flats*.

It is a good idea to have two brushes of approximately the same size, one for light color and the other for dark — for your smaller ones, Nos. 2 and 3; for the next size, 4 and 5; and for the larger sizes, 7 and 8. For very fine lines you could buy a No. 1 brush, but you will be able to get a fairly fine line by using the side of your larger brushes and will rarely need a small brush. It is better always to use as large a brush as possible in order to cover your canvas rapidly and to keep your picture broad and simple.

You will need a single oil cup about two inches in diameter and a palette knife of the trowel type, with the knife surface a little below the handle. This type of knife is easier to use than the straight type, and you get less paint on your hands (Fig. 1).

The list of colors in the Ballinger Palette is a simple one. It consists of ultramarine blue and cerulean blue, zinc white, cadmium yellow pale, cadmium orange, cadmium red light, cadmium red medium or dark and alizarin crimson. There are no earth colors, greens or black.

These are the colors you will employ most of the time. In addition, you can buy phthalo blue and viridian, though you will seldom use them.

Medium is the liquid you mix with your paint when you apply it to your canvas. I use a combination of linseed oil and turpentine, half and half. The oil should be a purified linseed oil obtainable from any art materials store; any clear gum turpentine sold by paint stores is adequate. You will also need retouching varnish. This is a light, quick-drying varnish to bring a gloss to the parts of the picture that

FIGURE 2

look dull and lifeless. It can be sprayed on by a fixative blower or applied with a clean, soft brush if the painting is dry. You will need only the retouch varnish when the picture dries out and you want to continue painting on it.

One other useful piece of equipment is a view finder (Fig. 2). This is simply a piece of cardboard with a rectangular opening in it and a wide enough border around the opening to blank out all but the scene that you are viewing. When you are sketching outdoors there is so much to see that it is often difficult to decide what to include in your picture and what to leave out. The view finder will help you isolate your projected composition.

The last item to consider is what to paint on. Canvas mounted on a cardboard panel is good because it is easy to transport. For larger sizes — 20 x 24 inches or over — I would suggest a stretched canvas. Panels the size of your sketchbox are handy because you can carry them in the lid of your box, which has slots for that purpose. Some of my friends use Masonite panels cut to a desired size. They are practically indestructible, but I don't like the surface — one side is too smooth and the other too rough.

At this point I would like to list a few terms that artists use in describing pictures, which otherwise may be confusing to the beginner. Artists are constantly talking about *warm* and *cool* colors in their pictures. This means exactly what it says. The warm colors are red, yellow, orange, yellowish green, reddish purple and the browns or grays in which the warm colors predominate. The cool colors are the blues, bluish greens, blue-purples and all the bluish grays.

By *value* we mean the degree of light and dark of any particular part of a picture or color. It also means the degree of light or dark of one color compared to another. *Tone* means about the same as value. *Half tones* are the values in a picture that are neither light nor shade — the values that are between the light and dark masses.

Key means the color value of the picture. A high-keyed painting would be one with light, bright colors, while a low-keyed picture would have dark, sombre colors.

2: *Simplified Approach to Composition*

THE FIRST THING TO CONSIDER in any picture is composition, that is, the dark and light pattern or design of the picture. Color alone won't make a good picture unless you also have a pleasing balance of the masses. I always try to think of every scene that I paint as a big, simple arrangement in two tones of light and dark (Fig. 3). This is the framework for the whole picture. I try to see every portion of the picture either as part of the light or of the dark pattern. I always "tie" my darks together by having one dark spot blend into or overlap an adjoining one to make a large, irregular shape of dark rather than a number of isolated spots (Fig. 4 A & B). Tie up the light spots in the same manner. The dark pattern, of course, makes the light one.

By thinking of the picture as a two-tone pattern of light and dark, you start with a simple poster-like arrangement (Fig. 5). There is so much detail in nature that it is a great help to start a picture in simple masses and then, as you work along, modify some of the darks and lights, adding detail where necessary (Fig. 6).

There are a few standard forms of composition that are often used in the structural design of most pictures, but before we discuss them I would like to explain what is meant by balance in a picture.

Pictures are composed on the principle of the steelyard balance. If this term is confusing, think of the old idea of the seesaw: an adult has to sit well in toward the center to be balanced by a child out on one end of the seesaw. Applied to a picture, a large mass of either light or dark near the center of your picture can be balanced by a small spot out near the edge (Fig. 7).

It is easy to see a two-toned pattern of light and shade in a harbor scene on a bright day. As a rule, the sky and its reflection in the water

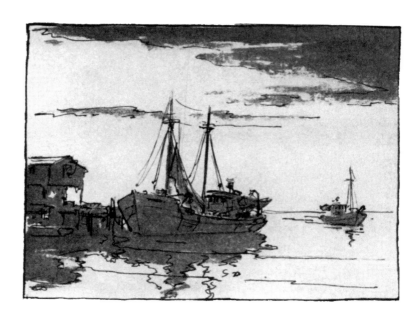

FIGURE 3

will be part of the light pattern as will light pilothouses and the super-structure of the boats or those parts of buildings or wharfs that are in sunlight.

The darks will be in the hulls of the vessels, dark shadows under wharfs, reflections in the water and those parts of buildings and wharfs in shadow (Fig. 8).

A popular type of composition is a light picture with balanced spots of dark (Fig. 9).

Many pictures are painted with the same composition in reverse, that is, a dark picture with balanced light spots — for example, the light boats and wharf in the upper left balanced by the rowboat in the lower right (Fig. 10).

A composition with a dark base and a light upper portion is effective; so is the same in reverse — dark top and light lower portion (Figs. 11 & 12).

A pyramid composition with the weight and interest building up the middle is always strong and effective (Fig. 13).

There is also the L-shaped composition which builds up one side of the picture (Fig. 14).

I often use the S-shaped composition in which the interest swings through the picture from top to bottom like the shape of the letter S. It is always pleasing (Fig. 15).

16

Sometimes the picture can be arranged in horizontal bands of alternate light and dark (Fig. 16).

A circular design is good because it keeps the eye in the picture and concentrates attention on the center of interest (Fig. 17).

Often a combination of several of these compositions can be used in the same picture (Fig. 18).

The difference between drawing and painting becomes apparent when you paint in masses of light and dark without any outline — when you draw you are working simply in line and outline with very few values.

FIGURE 4A

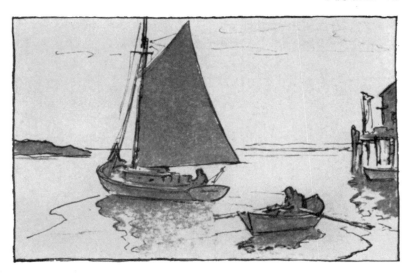

FIGURE 4B

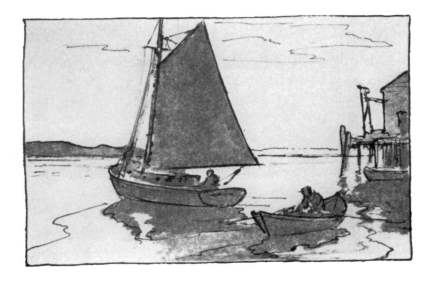

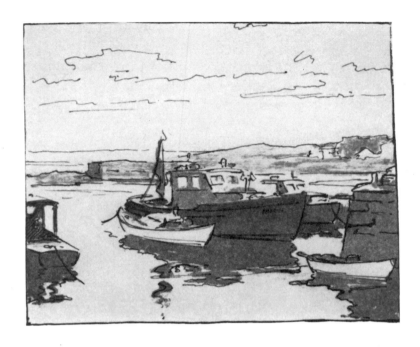

FIGURE 5

PIGEON COVE, AFTERNOON

FIGURE 6

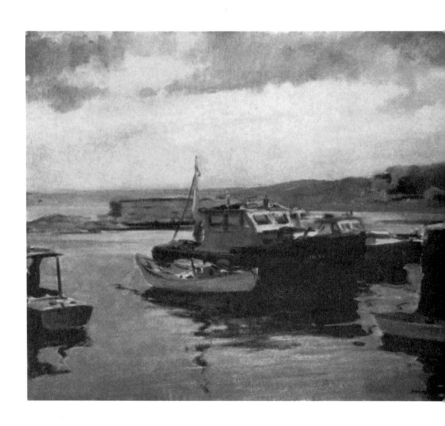

If you are able to get a fine decorative arrangement in your picture, you will have a good painting, but if the composition doesn't balance or work out in a decorative design, it is useless to struggle with it — the picture will never be any good. You might just as well give it up and try another from a different angle.

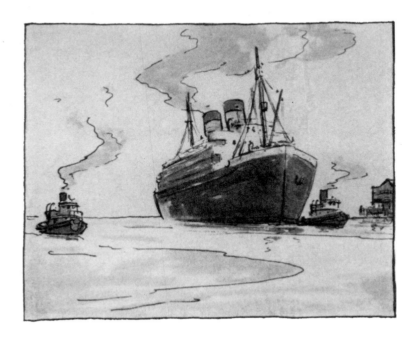

FIGURE 7

FIGURE 8

ALONG THE WATERFRONT

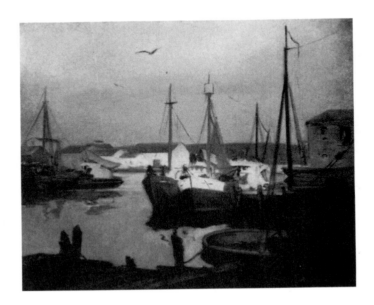

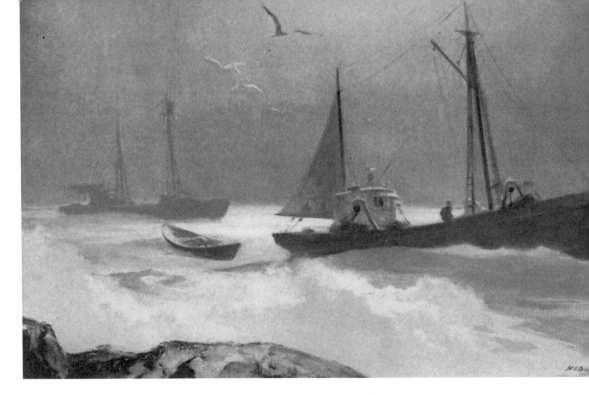

FIGURE 9 MAKING PORT

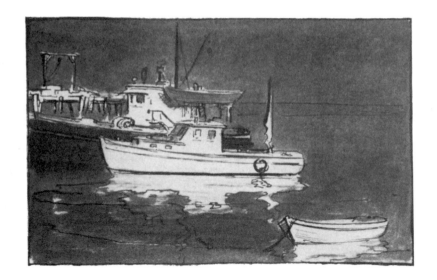

FIGURE 10

One way of learning about composition is to study every fine picture that you see and try to figure out what makes it good. Decide what kind of composition was used in its construction. By studying other paintings you can see how the principles of balance and composition which I have been discussing can be applied to your own picturemaking.

20

SIMPLIFIED PERSPECTIVE

Perspective plays an important part in every picture, so I will try to explain its general principles.

The receding lines of all objects in a picture converge at a point on the horizon line at the level of your eye. Your eye level determines the horizon line since the eye line and the horizon line are the same.

FIGURE 11

FIGURE 12

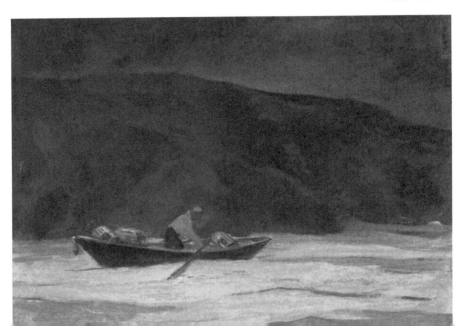

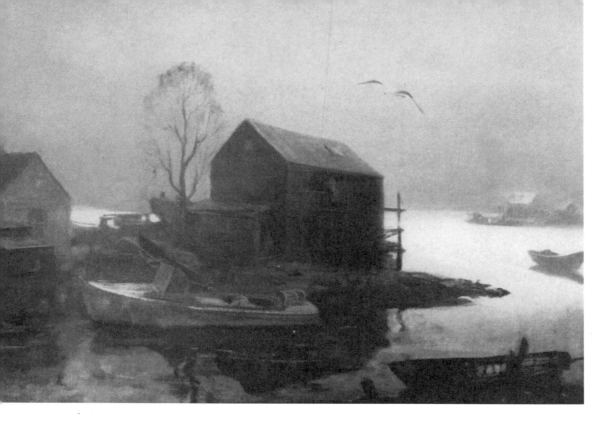

FIGURE 13 BACK BAY, ESSEX

Every receding line above your eye level comes down to the horizon, while all receding lines below go up to it. A figure standing on a dock would see a higher horizon line than a figure seated in a rowboat (Fig. 19).

Nearby objects below the level of your eye seem to tip down to form a more exaggerated angle with the horizon line as they get nearer to you. They flatten out as they recede toward the horizon line. The same is true of objects above the eye line. The lines of buildings slant at a more exaggerated angle near to, but flatten out as they approach the horizon (Fig. 20).

Clouds have more sweeping curves overhead, but are flatter and closer together as they approach the horizon.

If you wish to learn more about perspective there are a number of books available on the subject. Try to get one that you can understand. I must admit that most of them seem rather complicated to me, but if you stay with it and keep in mind the few simple ideas that I have listed above I'm sure that you will be able to work out the perspective in your picture without too much of a struggle.

22

FIGURE 15

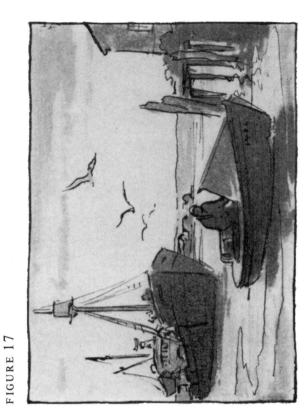

FIGURE 17

FIGURE 14

FIGURE 16

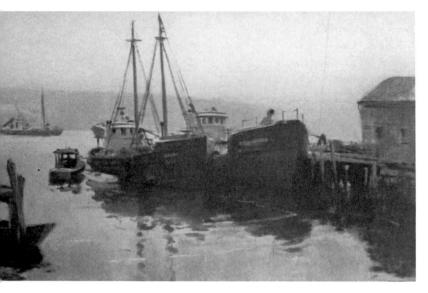

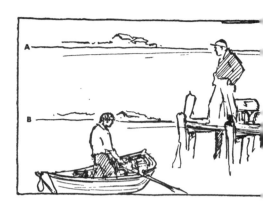

FIGURE 18 MORNING HAZE FIGURE 19

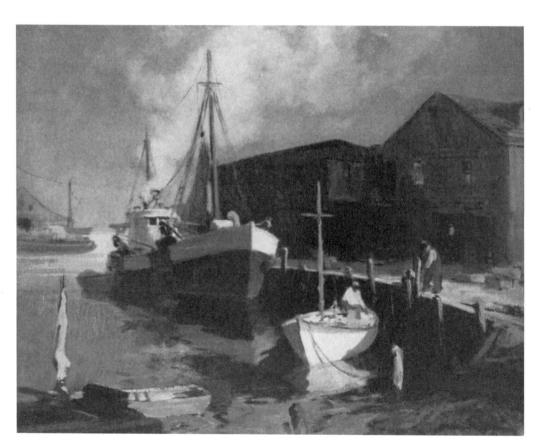

FIGURE 20 THE SEINE BOAT

24

3: *Color Mixing—Using the Ballinger Palette*

I BELIEVE THAT IT IS BETTER to use a simple selection
of colors for your palette than to use every color under the sun.
When you mix two colors to make a third, you get more sparkle and
freshness than if you use a corresponding color right out of the tube.
My choice of colors, which has been called the Ballinger Palette, is
simply the standard high-keyed palette, with no green, purple or black
and no earth colors.

Before even attempting to paint, you have to learn to mix color.
Until you learn to match the color that you see before you with your
paints, you won't be able to paint anything the way it looks to you,
for mixing a desired color is a matter of practice and study. I suggest
that you spend some time trying to match in color and value every
color in your living room. Try to match the color of the ceiling, walls,
floor, draperies and furniture. Match the general color of the carpet,
for instance, both in the light and in the shadows. Try the same idea
outdoors. Don't draw; just match the colors you see in front of you —
the color of the grass, trees, houses, etc.

Most beginners can identify correctly a color that they see in front
of them but are unable to combine the pigments on their palette in
the proper proportions to produce the desired color.

There is one thing to remember: go gently when you are trying to
mix a color; sometimes just a touch of color on the corner of your
brush will be all you need. Compare the color that you are mixing
with the color in front of you — put them side by side. If your color
is too light, add more paint; if too dark, add white; if too warm, add
more cool color. While it does take practice to match the exact color
and tone that you see before you, it can be done with perseverance.

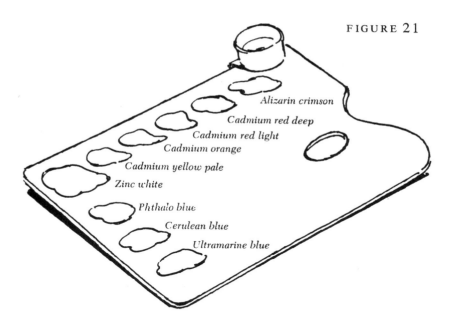

FIGURE 21

Alizarin crimson
Cadmium red deep
Cadmium red light
Cadmium orange
Cadmium yellow pale
Zinc white
Phthalo blue
Cerulean blue
Ultramarine blue

The colors should be arranged on your palette starting with the cool ones on the left, white next, then the warm ones, arranged in the order of the color wheel (Fig. 21).

1. *Ultramarine blue.* This is a dark, purplish blue which, combined with red, can be used for strong darks. I use the blue to darken the color, then add cadmium red deep, cadmium red light or cadmium orange, depending on how warm a dark I desire. As a rule, I like to have my darks a little on the warm side to give them more richness and depth than if they were a cold blue or purple.

2. *Cerulean blue.* This is a paler, more greenish blue and makes lovely, pearly grays when combined with cadmium red light and white. If you desire more of a tan color, add a little cadmium orange to your gray mixture. However, don't add cadmium yellow pale, as this will immediately produce a greenish tint. Cerulean blue is a very useful color as it is already grayed up as it comes from the tube and can be used to gray up other colors or combinations of colors. It makes a fine light green when combined with cadmium yellow pale. For darker greens you can use ultramarine blue and cadmium yellow pale and for a very dark olive-green, use ultramarine blue with cadmium orange.

26

3. *Phthalo blue* and *viridian*. Once in a while you can use a little phthalo blue or viridian for some special spot, but I don't think you will need either of them often. Phthalo blue is a powerful dye, like Prussian blue, and should be used with restraint. Sometimes a little mixed with white will make a strong, very light blue that can be used in painting a sky. For ordinary use it is too powerful for the other colors in your palette.

Viridian is a pleasant blue green and is useful in painting parts of a cresting wave in a surf scene or the dark green in the quiet water of a harbor.

4. *Zinc white*. This should be fairly liquid so that it will mix readily with your colors and flow on easily. Of course you can use it to gray up your colors when you are mixing lighter hues, but don't mix too much white with your color because you are liable to give a chalky look to your painting. For instance, you can get light enough greens by using cadmium yellow pale with your blue, which is a nice light color, without using any white at all.

5. *Cadmium yellow pale* is like a lemon yellow. Be sure that they don't sell you cadmium yellow *light* at the art materials store, as this is a warmer color and doesn't work as well as cadmium yellow *pale*.

6. *Cadmium orange* is just about the warmest kind of yellow. By mixing different quantities of cadmium yellow pale and cadmium orange, you can get any degree of warmth that you desire in your yellows.

7. *Cadmium red light*. Be sure it is a bright orange-red, like vermilion.

8. *Cadmium red deep* or *medium*. Either of these is all right for use in your dark reds or combined with ultramarine blue to make black.

9. *Alizarin crimson*. I prefer this to rose madder because it is a more permanent color. I use alizarin crimson only occasionally in a picture. In painting, as in life, there shouldn't be too many purple passages. However, there are some occasions when alizarin crimson is very effective. Diluted with white you can get some nice rose pinks; mixed with cadmium red light, it makes a strong and brilliant red.

Here in brief is the way to mix some of the colors you will use most often:

Black. Ultramarine blue and cadmium red deep, with just a touch of cadmium orange, will give the effect of black paint, but it will have

more brilliance than black paint, which generally has a tendency to resemble shoe polish.

Darks. For dark reds or browns, use ultramarine blue with cadmium red deep or cadmium red light to warm it up. For browns, use a little orange and less of the blue. For dark blues, use less of the warm colors; for dark greens, ultramarine blue with cadmium orange and sometimes a little cadmium red light. Don't mix alizarin crimson with ultramarine blue unless you want to get a rip-roaring purple.

White. Use zinc white, of course, generally with just a touch of warm or cool color, because whites in nature are seldom exactly white.

Grays. Mix cerulean blue and cadmium red light with white.

Tan. Add a little orange to the above gray mixture.

Greens. For light greens, use cerulean blue and cadmium yellow pale; for darker greens, use ultramarine blue instead of cerulean. If you want a dark olive green, use ultramarine blue combined with orange.

When you are mixing a color, try not to mix the paint too thoroughly on your palette. You will have more color vibration, when you apply paint to the canvas, if it isn't overly blended. You will get an effect of broken color which will give a sparkle to the picture.

Usually, when you finish a day's painting, you clean off only the center of your palette, leaving the gobs of color around the edges. They will usually stay fresh for several days, so the paint won't be wasted. If you use a disposable paper palette, you can transfer the piles of paint to a fresh sheet and throw away the old one.

When I finish the day's painting, I always place my brushes in a flat tin of kerosene with the handles resting on the edge of the pan and the bristles lying flat on the bottom of the pan. This is much better for the brushes than standing them upright in kerosene, which is liable to bend and distort the bristles.

When you want to use your brushes again, just wipe them off with a rag and they will be ready for work. Every two or three weeks you can give them a real wash with brown laundry soap and water. Take care to rub the soap into the bristles right up to the ferrule of the brush so that no paint will harden in the bristles to spoil your brushes. Your brushes will last longer this way, as constant washing with soap and water is apt to wear them out. Too much washing of your brushes is also bad for your hands and your disposition, situations to avoid at all cost!

4: *Direct Painting with Oils*

WHEN YOU HAVE MADE UP YOUR MIND what you are going to paint, wade right into it and paint it while you are still full of enthusiasm for your subject. A picture that is of interest to the artist is generally of interest to everyone else.

It is also a fine thing to finish the picture, if possible, while you are still excited about it, as it usually has a dash and brilliance that is hard to achieve in a worked-over job. I find that when I spend too much time on a picture I lose interest in it and the thing begins to fall apart.

Generally I try to lay in most of the picture at one sitting, so that I have only details to finish up later. This means trying to hit the exact color and value of each part of my painting as I go along. First, I figure out the arrangement of all the objects that are to go in the painting, taking care to arrange them as decoratively as possible. Next, I draw in the outline of all the big masses of light and shade in the picture. Then I start painting the sky and its reflections in the water, because the sky sets the key for the whole painting (Fig. 22).

Now lay in the dark masses, starting at the center of interest (Fig. 23). Try to get the right values and color as you go along. Next put in the medium tones, comparing them to the lightest lights and darkest darks. Be sure to keep the dark pattern simple and don't break it up with too many lights. The same thing applies to the lights — be careful not to get the half tones in the lights too dark, as they will break up the light pattern and spoil the design of the whole picture (Fig. 24).

So far, in my suggestions about painting, we have just talked about the dark and light values of the picture. Now we must take up the problem of color. While the values in your picture are perhaps more

FIGURE 22*

FIGURE 23*

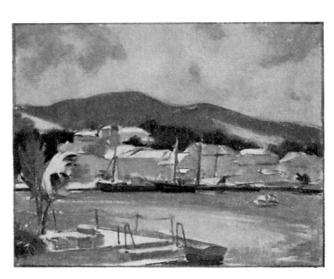

important to consider at the start as they are the framework upon which you construct the whole painting, you must, nevertheless, have a fine, harmonious color scheme as well. The first thing that attracts anyone's attention is color. I know a number of artists who seem to have a natural color sense and whose pictures are consequently lovely

* See color insert between pages 32 and 33.

30

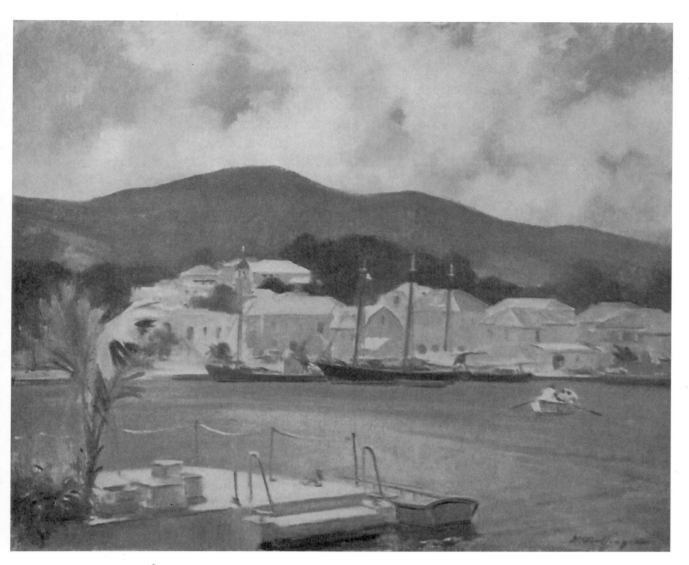

FIGURE 24* CHRISTIANSTED HARBOR

to look at. While possibly some of us have only moderate gifts in the color line, still, with practice and study, almost anyone can paint a picture that is pleasing and harmonious in color.

Some beginners try to fill their pictures with every kind of color in the world — all of it nice and bright and right out of the tube. In

* See color insert between pages 32 and 33.

31

fact, the greater variety of colors they can get into a sketch, the happier they seem to be. But it is safer to use only a few colors. The picture will look less confusing and have more harmony.

Always try to consider color in a picture as being either on the warm side or the cool. The most effective pictures are either predominantly warm with a few cool accents or else cool with warm spots. Do not have too equal a division of warm and cool color in a picture because the effect isn't as striking as when one or the other predominates.

Most of the color in a picture is a little grayed up, and strong color is only used in a few accents, mostly in the foreground.

After studying the color in the scene you are to paint, try to decide whether the important colors in the scene are warm or cool. If it is hard to decide whether an area is on the warm side or the cool, compare it to the more brilliant colors in the picture that are definitely warm or cool. In this way you can usually decide which way to slant the color.

Remember to keep your color clean and fresh-looking by mixing only a little of it on your palette and by applying the paint directly to the different areas of the painting — then not working over it any more than necessary.

Direct painting requires good draughtsmanship. You can't slop around any old way and hope for the best. You have to know exactly what you want to do and do it without any waste of time.

You can't paint faster than you can think. This means that you have to decide in your mind what you want to do before you do it. Your thinking has to keep ahead of your brushwork.

While some very fine pictures have been made by underpainting and glazing, that type of painting is more for studio work. Certainly, direct painting is the only practical method for outdoor work.

COLOR PLATES

CHRISTIANSTED HARBOR

CHRISTIANSTED HARBOR

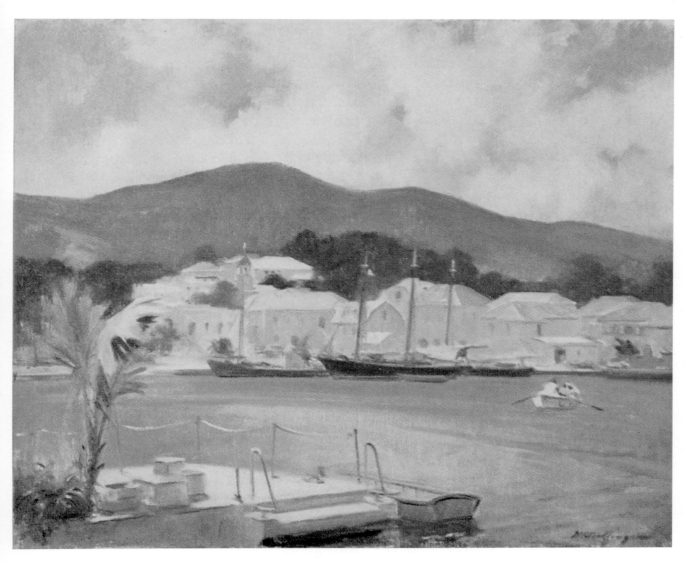

CHRISTIANSTED HARBOR

THE GREEN BOAT

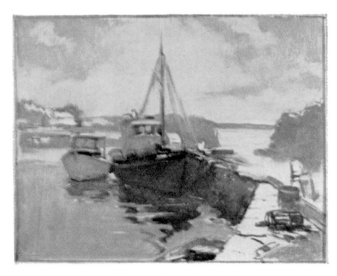

THE GREEN BOAT

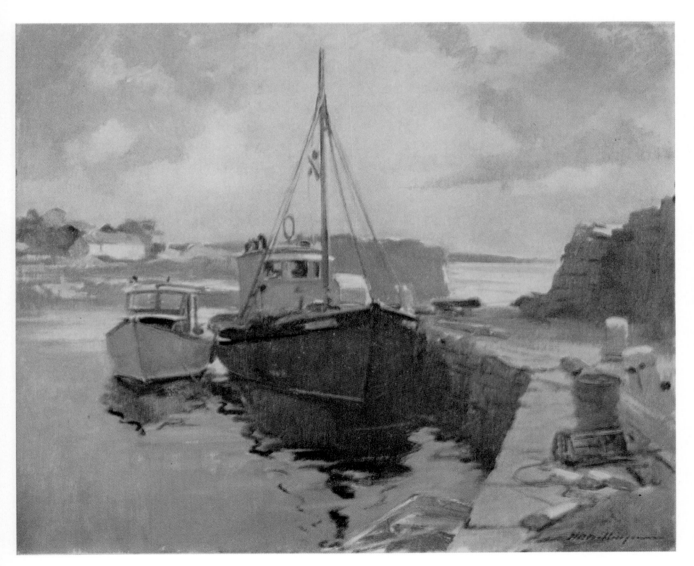

THE GREEN BOAT

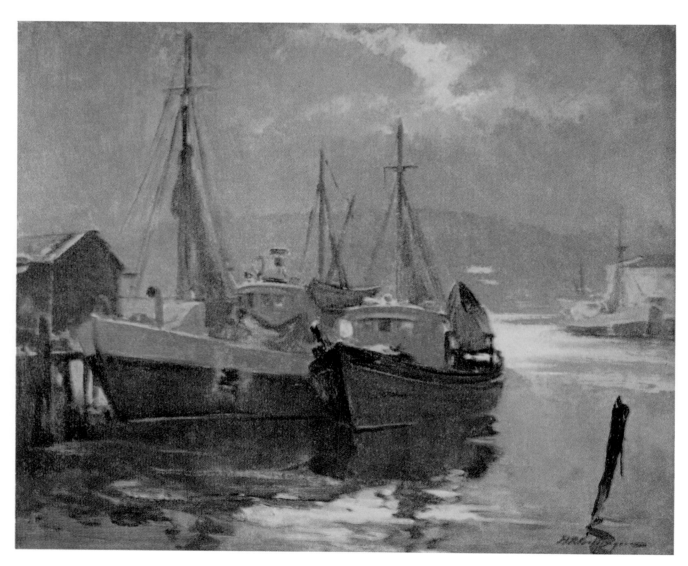

MOONLIT HARBOR

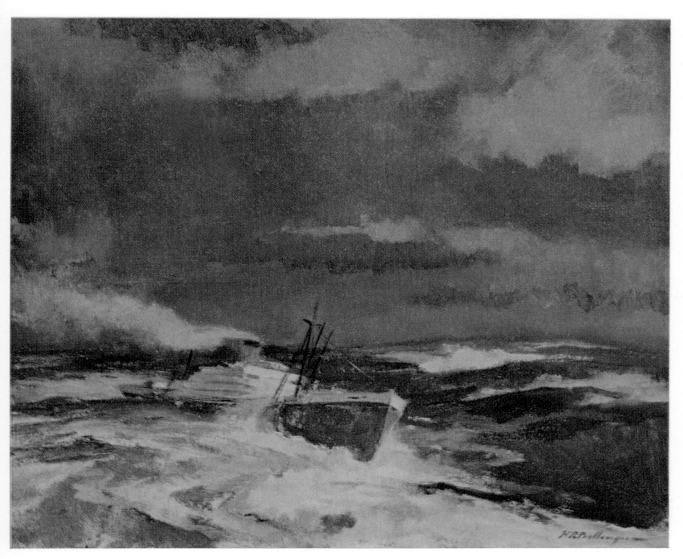

HEAVY SEAS

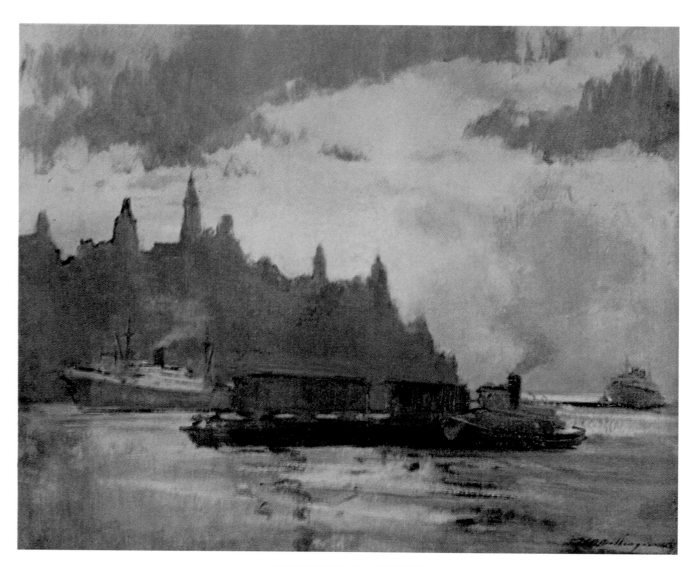

MANHATTAN SKYLINE

5: *Drawing Boats*

THE AVERAGE LANDSMAN doesn't know very much about boats, although I doubt if he is in the class of a former Secretary of the Navy. This great man was reported to have said the first time he saw a submarine surface and some of the crew come out of the conning tower, "Gosh, the darned thing's hollow."

Well, let's start from there. Yes, boats are hollow and float *on* and *in* the water. The simplest way to think of a boat is that it is a long, narrow box with one end pointed. Probably the first boats were just hollowed-out logs with pointed ends or crude rafts without any pleasing lines at all.

Although occasionally you see someone paint a harbor scene in which the boats bear a strong resemblance to canoes, gondolas or the type of craft used by Columbus when he discovered America, fortunately it is not necessary to go back to the early days to find interesting ships to paint. Our present-day boats are picturesque and fascinating enough to suit anyone so we'll just concentrate on them.

Boats can be divided roughly into two categories — small boats that operate off a beach or in harbors, and the larger, seagoing ships that are at home in deep water.

Before going any further I would like to mention some of the simpler nautical terms with which we should all be familiar when describing boats.

The front end of a boat is called the *bow;* the rear portion, the *stern.* When we speak of going or looking toward the rear of a ship, we say "going aft" or "looking aft" or the "after" part of the ship, and when going toward the front, we speak of the "fore" part of the boat or "going forward." The expressions *fore* and *aft* mean bow and stern.

FIGURE 25

FIGURE 26

The width from side to side is called the *beam*.

The floor is always called the *deck*. The sides of an open boat are called the *gunwales*.

The right side of a boat looking forward is called the *starboard side* and the left, the *port side*. The rudder and steering gear are called the *helm*. The man who steers is the *helmsman*.

It isn't necessary to know all the technical details about boat building in order to paint boats convincingly, so without getting too involved in marine construction I will try to explain in the simplest possible manner the important characteristics that you will have to remember when drawing a boat.

You have to be familiar, first, with the shape of the boat; next, the way she sits in the water and, then, the general purpose of her fittings and equipment.

The frame of a ship looks a little like a human skeleton, the keel and timbers resemble the ribs and backbone of a person. At one end of the keel is the stem, at the other, the stern post. The closely-spaced rib timbers are in between (Fig. 25).

34

Every part of a boat is designed either for utility, added strength or seaworthiness. The bow of a boat stands higher out of the water than the stern in order to ride the waves better.

The line of the deck or *sheer line* has a pleasant dip from bow to stern which must be thoroughly understood and carefully drawn, as it determines the appearance of the whole vessel. The lines of a boat are usually long, sweeping curves rather than straight lines (Fig. 26). I think that this is one reason the inexperienced marine painter has so much trouble with boats — he tries to draw them with straight lines, the way he would draw a house, rather than with curved lines.

The stem of a boat, that is, the piece of timber running up the bow of the boat, is clearly visible from the outside. While some small boats — like lifeboats and seine boats — are double-ended with the rudder attached to the after end (Fig. 27), most boats have squared-off or rounded sterns.

One familiar type of stern looks as though the rear of the boat had been sawed off at a slightly sloping angle. This is called a *transom stern*. From the rear it looks a little like a wineglass.

Another variation is the counter-stern, which continues out for some distance past the rudder and overhangs the water. This is a particularly graceful style of stern and is often seen in racing yachts

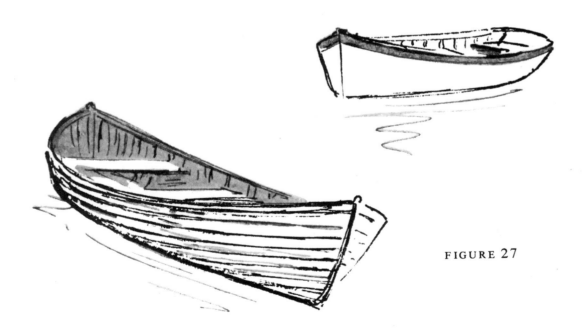

FIGURE 27

in an exaggerated form. Another type gives the ship a rounded end which overhangs the stern post and provides a maximum amount of deck space (Fig. 28).

There are two chief methods of planking a wooden vessel, the *carvel* and the *clincher-built*. In the carvel the planks are laid edge to edge which gives a smooth-sided effect, while with the clincher-built the planks overlap. This latter system is seen in dingies, rowboats and small coastal fishing boats (Fig. 29).

On the outside of the hull, at the deck level, you will notice a heavy piece of molding. This is called the *fender rail* or *rubbing strake* and protects the hull from rubbing and from the minor impacts that all boats must sustain. Often this molding is covered with a flat strip of iron to give greater durability and added protection.

All boats, with the exception of barges or flat-bottomed rowboats, have a keel which is an integral part of the boat. In sailing boats, the keel prevents the boat from sliding bodily sidewise to windward. In all types of vessels the keel, of varying depths, adds to the maneuverability of the boat and makes it steadier and safer at sea (Fig. 29).

When drawing a boat you have to keep in mind where your eye line or the horizon line is, and then you must study the sheer of the boat. Usually, owing to the high bow and the comparatively low

FIGURE 28 FIGURE 29

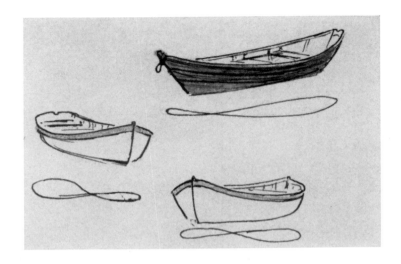

FIGURE 30

stern, the top lines of the hull instead of going up to the horizon line as they recede, often slant the opposite way, going down as they recede. As it recedes the water line of the vessel, however, goes up to meet the horizon line in the expected direction (Fig. 18).

Small boats also have fascinating lines but a flat-bottomed skiff hasn't quite as graceful a sheer as a dingy or an ordinary rowboat. A popular type of rowboat, the dory, is also flat-bottomed with a very narrow stern which makes it look almost double-ended. It is sturdily built, will stand rough usage and is a fine seaboat.

It may help, when drawing the sheer line of a boat, to think of a figure eight. Sometimes the figure isn't easy to see, but it exists in rhythm just the same (Fig. 30).

When drawing a boat that is a little foreshortened — one that is pointed slightly toward or away from you — be careful not to have the water line of the ship point down too sharply as it approaches you, because this is liable to make the water tilt down and not lie flat on the water plane. It is only when you are looking down on a boat quite nearby that you have very exaggerated perspective. Farther off, near the horizon, all lines are practically horizontal anyway with very little drop to them as they approach.

Be sure to remember where your eye or horizon line is when drawing boats that are different distances away in a harbor. If, for

37

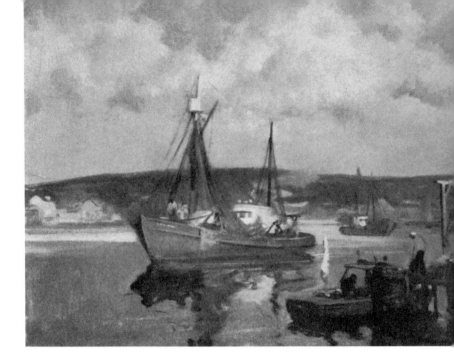

FIGURE 31 GLOUCESTER DRAGGER

FIGURE 32 BEFORE SUNRISE

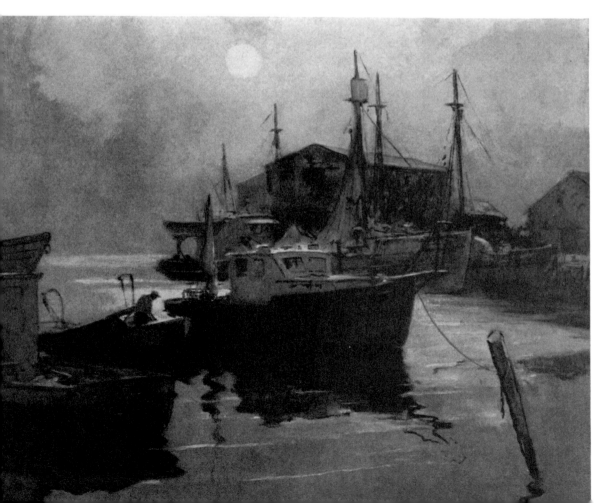

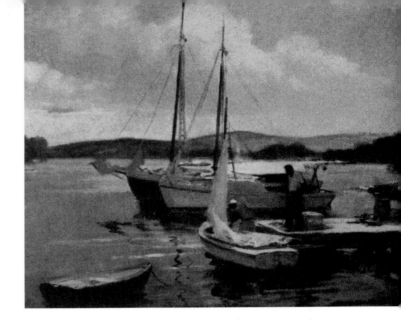

FIGURE 33 ST. CROIX

instance, your eye line is that of a man standing on the deck of a ship, the eyes of all other men standing on a deck of the same height would be on the same level no matter where they were in the harbor. Everything below your eye level would go up to the horizon line as it receded and everything above would go down to it. For instance, the top of a pilothouse, being above your eye line, would slant down toward the horizon; halfway across the harbor it would be nearer the horizon line, hence more nearly horizontal, but still above it (Fig. 31).

When painting boats in the comparatively still water of a harbor, always consider the reflections of the vessel in the water as an integral part of the boat and draw in the reflections at the same time that you are drawing the boat (Fig. 32). We shall discuss the painting of reflections at greater length in the next chapter.

Sailboats are the most decorative kind of boats and it is a shame that, except for pleasure yachts, they are rarely seen any more (Fig. 33). I wish that this book could have been written fifty or sixty years ago when there were still sailing vessels along the coasts. There are still a few small sloops and schooners in the Caribbean and other less civilized spots and we shall talk about them in a later chapter.

The masts and superstructure of a boat are important since they add greatly to the decorative appearance of the ship.

In sailing vessels, masts are still used for their original purposes to support the sails, but in all other types of vessels that do not depend on sails for locomotion, the masts are used mainly as hoists for handling cargo or for displaying flags, lights or signals.

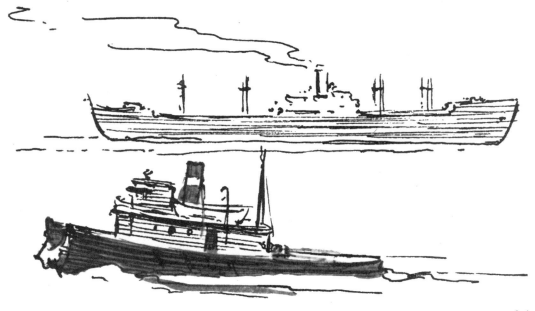

FIGURE 34

The superstructure always includes a wheelhouse or pilothouse, cabins for officers or crew, and space for portions of the engine or motor. Sometimes this deckhouse is amidships and sometimes aft, depending on the type of vessel. Most small or medium-sized trawlers or draggers have the pilothouse and the rest of the housing at the stern to allow more room for handling cargo (Fig. 31). Tugs have the deckhouse a little forward of amidships, while most freighters have the bridge, pilothouse, and cabins amidships (Fig. 34). Oil tankers sometimes have the bridge, pilothouse, and cabins amidships and the smokestack, deckhouse, and lifeboats at the stern (Fig. 35). Most passenger lines and passenger-carrying freighters have the superstructure amidships (Fig. 69).

FIGURE 35

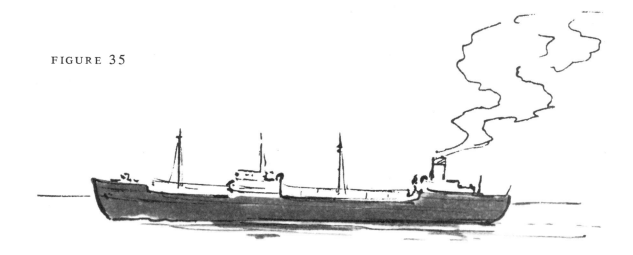

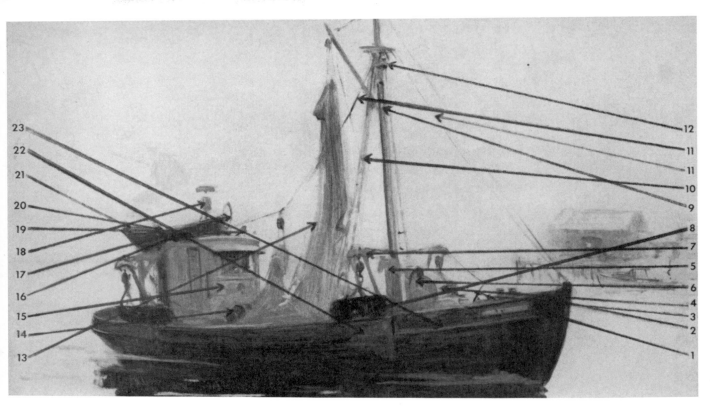

FIGURE 36 A SMALL DRAGGER - DIAGRAMED *(see text below)*

It helps in drawing a ship if you know what the more important pieces of equipment are used for — so let's consider a small dragger, and I will explain the function of the different objects that you see cluttering up the decks. From bow to stern we see (1) *hausehole*, (2) metal posts for making lines fast called *bits*, (3) *anchor*, (4) *forward hatch* leading to the cabin below, (5) tin stovepipe of the cooking stove, called the *galley stack*, (6) *ventilator*. (7) *Hoists* or *galluses* are used in seining. They carry the strain of the nets and the wooden boards called (8) *doors* that keep the mouth of the nets or "drags" open. (9) *Mast* with *boom*, (10) rope ladders called *ratlings*, (11) ropes that support the masts called *standing rigging* and lines for handling gear called *running rigging*, (12) *masthead light*, (13) nets drying in the sun, (14) *windlass* or *winch* used for handling nets or unloading cargo, (15) pilothouse with (16) running lights and wooden shields, (17) radio compass and antenna, also (18) radar equipment and (19) spotlights on the roof, (20) muffler and exhaust pipe for motor, (21) *dory* on wooden supports at the stern. Below each hoist up forward is an iron sheathing (22) that protects the hull from damage when hoisting the heavy doors aboard ship. This sheathing

41

generally loses its paint and gets rusty, forming a nice orange-red spot of color to break up the ship's side. Nowadays, as a rule, the dory and masts are painted a bright orangy yellow for better visibility at sea. The *fender rail* (23) is at deck level; above it are the *scuppers* which are openings to allow water to drain off the decks.

6: *Painting Harbors*

Reflections. When painting the more or less still water of a harbor, it helps to think of it as a large, flat mirror in which everything above is reflected in the water below. Because the water usually presents a level surface to the sky, it will take on the modified color of the sky except close at hand, where you look right down into the water and see the greenish color of the water itself or of the muddy or sandy bottom.

If you keep in mind a few simple facts about reflections, I am sure that you won't have too much trouble painting them. Remember that the reflection of every point is located underneath it as far below the water line as the point is above it (Fig. 31).

Because water is not a perfect reflecting surface, light objects will reflect a little darker than they are; reflections of medium-toned objects, being neither light nor dark, will reflect exactly the same value as the object itself; dark values will sometimes reflect a little lighter than they really are. If your eye line is near the surface of the water, any object will reflect a perfect inverted image of itself in the water. Since your eye line usually is considerably above the surface of the water, the reflections of objects never look the way they do in direct sight.

When you look at any object and its reflection in the water, the object is seen directly by the eye, while the reflection is viewed in an indirect line that runs down to the surface of the water about midway between you and the object, then continues upward from the surface of the water to the object reflected. In the line of reflected sight the angle of incidence from the object to the water is equal to the angle of reflection from the object to the observer (Fig. 37). Things that

FIGURE 37

FIGURE 38

A

B

FIGURE 39

44

FIGURE 40 ARNOLD'S WHARF

are in sight by direct vision are often not reflected in the water and, inversely, the underside of a wharf will be seen in the reflection. You appear to be looking up at an otherwise invisible object.

The sketch of the dory shows the difference between the way the boat looks in direct vision and the way it is reflected in the water (Fig. 38).

To determine the length of a reflection, remember the previously stated rule: "the reflection of an object is located directly underneath and as far below the reflecting surface as the object is above it." For example, a single pile set vertically in the water has a perfect inverted image. But, when a pile leans toward you, its length above the water is slightly foreshortened. The length of the reflection, therefore, is

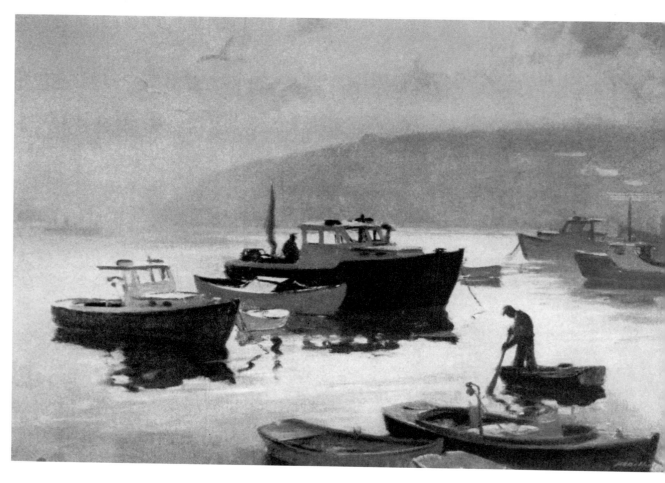

FIGURE 41 PIGEON COVE *Collection, Dr. Clifford Hiles*

longer than the apparent length of the pile. You will find the proper length of this reflection by observing the distance from the top of the pile to the water directly beneath it, and, following our rule, the near end of this reflection is the same distance below the reflecting surface as the top of the pile is above it. In the case of a pile that is tilted away from you, its reflection is shorter than the pile itself. You will see the application of our rule about reflections as you study the sketch of the piles (Fig. 39).

Still Water. When painting the still surface of a harbor you will notice that the water near you appears darker when you look down

46

into it because there is less reflected light from the sky to brighten it. A little farther from you the water is lighter with an occasional brilliant reflection on some of the ripples. Still farther from you the water may look slightly darker with alternating strips of lighter and darker tones. These are caused by areas of smooth water in contrast to the rough areas that are ruffled by the wind. The smooth water reflects only the sky, while the rougher water reflects light from many directions. If the light source originates in the background of the picture, the rough water will pick up a brilliant glitter from the sun and will be lighter than the smoother portions that reflect the sky. Sometimes the rougher portions may be darker, according to the prevailing light effects. In any case, you can paint these areas like long, narrow, horizontal wedges, being careful to keep them narrower and closer together as they recede toward the horizon.

Even the comparatively still water of the bay is never completely still. There will always be small ripples coming in toward shore in parallel lines from the direction the wind is blowing or from the more open parts of the harbor. It is important to note the direction of these small ripples because they give a wavey, wiggly shape to the edges of

FIGURE 42

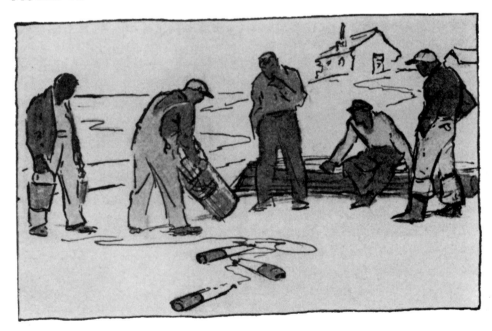

your reflections and add greatly to the charm of the scene. If these little waves are large enough, they will break up the reflections with some crisp, light, possibly horizontal touches that make an effective contrast to the vertical lines of the reflections. It is always a good plan to paint the reflections up and down using vertical brush strokes and to paint the ripples with horizontal strokes (Fig. 48).

Wharfs. Wharfs are fun to paint because they have dark shadows under them, and the piles covered with scum and seaweed are quite decorative. The planking of a wharf is laid on crossbeams that are bolted on to the supporting piles. Around the outside of the wharf you will notice a row of piles that are a protection for the wharf itself; they also cushion the shock when some mariner docks his ship with too much energy.

The cluster of piles at the corners of a wharf are for added strength. The taller piles are for mooring boats while the short ones are to protect the wharf. The old stone piers have piles along the edge to protect the ships that are tied alongside. The occasional wooden ladders reaching down the side of the wharf to the water add interest to the scene.

Shacks. The shacks and warehouses seen on the wharfs are often decrepit and very picturesque in appearance. Unfortunately the newer buildings are so clean and neat that they aren't too interesting to paint. Generally, I try to make the buildings on a wharf look as weathered as possible. Such a practice worries the proud owner of the property, who does not like to see his tidy new building suddenly look so old, but it does add to the fun of the painting and gives the picture much more charm and atmosphere (Fig. 40).

Human Figures. Figures add greatly to the picture's interest. Perhaps it is the human element that attracts one's attention, but I do know that the eye is immediately attracted by figures in a picture. They are the first things noticed and are always the center of interest. When you are painting a harbor scene, however, your chief interest should be a particular boat or a cluster of boats and perhaps some portion of waterside scenery, so you must be very careful where figures are placed. Preferably they should be placed near the center of interest, or where they will focus attention upon those parts of your picture which you wish to accent.

First, be sure that the figure is the right size, that is, in scale with its surroundings. Then, draw the figure in the pose and action that

you think will go well with the rest of the picture. Paint the figure as a simple spot or silhouette. Don't overmodel it or add too many details (Fig. 41). It is surprising how convincing a small figure looks when handled in this simple manner. The head and arms might be a medium dark spot, the shirt a flat dark note — perhaps red — and the trousers a lighter shade. Most of the time figures can be painted as slightly dark silhouettes. Only if they are in strong light against a dark background should they be lighter spots in a picture (Fig. 42).

Sea Gulls. Another way to add life and movement to a picture is to put in some sea gulls. They can be very effective and decorative if they are used in the right spots. Unfortunately, most of the gulls that you see in pictures seem to be all out of shape and resemble neither fish nor fowl. They sometimes look like fat, decrepit pigeons or mosquitoes that couldn't stay in the air for a second unless someone held them there.

A sea gull is a stupid bird without a trace of individuality. All he can do is to fly and swim a little. However, he flies and soars superbly and is very decorative. It will help if you remember that sea gulls are mostly wings, their bodies small and streamlined — never fat. The herring gull, most common along the New England coast, is brown and tan when young, but white and gray when grown, with black wing-tips (Fig. 43).

When painting a number of gulls slant them at different angles, and by having a number of their silhouettes overlap a decorative pattern can be arranged which will make an interesting design in your picture.

FIGURE 43

Harbor Scenery. It also adds interest to your picture to put in some of the picturesque junk that you see on some of the older wharfs — such objects as crates, oil drums and assorted barrels, lobster pots, hoists for unloading cargoes, old tarpaulins, ropes and nets.

I personally like to paint shipyards with a boat up on the ways, or rowboats pulled up on a shelving beach, showing also the small shacks nearby for storage of fishermen's gear.

There is something about looking at a peaceful harbor that is to me infinitely soothing and comforting. I think that it is good for one's soul. A painting of it often has the same restful effect. Perhaps this is the reason that harbor scenes are universally popular.

7: *Painting Skies*

IN A PAINTING THE SKY is extremely important for it provides the key to the whole picture. Therefore, it should be painted first. It will be helpful to picture the sky as a great dome.

There is a layer of vapor over the surface of the earth which grays up distant objects. When you look straight up into the sky, instead of looking at an angle, you see the peak of the dome through the clearest air, that is, you are looking through the thinnest portion of the vapor layer, consequently you see more of the true color of the sky.

Over the land this veil is a combination of dust and smoke. Over the sea it is vapor. In addition to graying up the distance, it sometimes reflects quite brilliant colors from the sun.

So you see, a cloudless sky isn't just blue all over. Its color is affected by the layers of vapor and by the sun. Directly overhead it is a darker, more intense blue which changes to a paler blue-green lower in the sky, until finally, near the horizon, it becomes a pinky lavender. Thus we see the sky appears darker overhead and lighter near the horizon. It is this gradation of color and tones which gives the sky its domed effect.

The warm light from the sun also affects the color of the whole sky so that you will find pink and pale orange modifying its blue tones.

When you are looking toward the sun, as you frequently do when painting a picture with back lighting, you will find that the sky is extremely warm and glowing in color. The sky can then be painted in tones of warm pink and yellow with hardly any blue showing at all.

When I am painting a picture with side lighting, I generally warm the sky as I get nearer the side from which the light is coming. Sometimes the sky opposite the sun will also receive warmth.

51

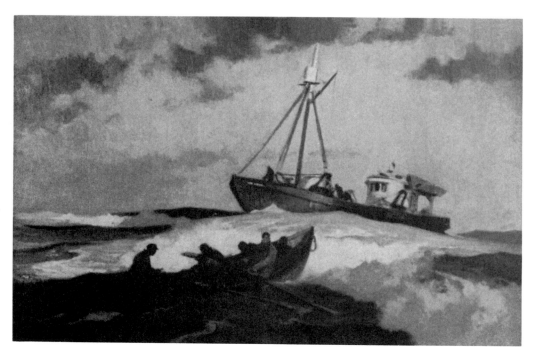

FIGURE 44 CREW OF THE MARY LOU

FIGURE 45 OVERCAST

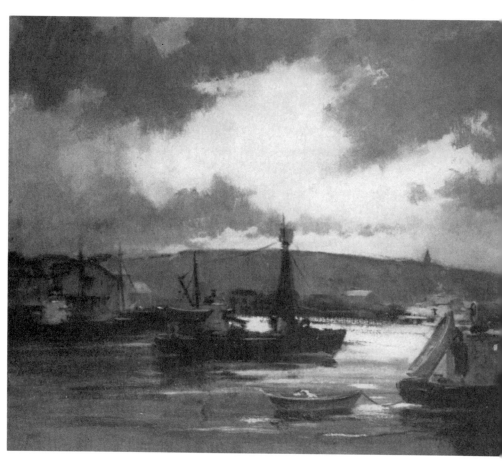

I believe it was Winslow Homer who disliked painting blue skies. I heartily agree with him; any color of the sky suits me as long as it isn't blue. A bright blue sky looks almost too "pretty," is reminiscent of calendar art. Fortunately, there is such a wide variety of skies to paint that, if you are lucky, you will hardly ever have to paint a blue one.

A cloudy sky offers the artist a much better opportunity to compose a fine decorative arrangement of light and shade. A cloudy sky makes it possible to use cloud shadows throughout the picture, and you can concentrate your light and shade exactly where you want it (Fig. 44). I personally think that good shadows are God's gift to the artist.

Clouds form and float at approximately three different levels — high, middle and low. There are three types of low-lying clouds: *stratus* — flat, layer-like clouds, generally quite low and extending horizontally over a relatively large area; *cumulus* — the puffy, woolly type having a flat base and piled up like mountains; and *nimbus* — the rain cloud, uniformly gray and extending over the entire sky. There can be combinations of these different types of clouds as *cumulo-nimbus* or thunderhead *nimbus; cumulo-stratus* — a *cumulus* whose base spreads out horizontally covering the whole sky in a gray mass.

The middle level clouds are called *alto* and consist of *alto-cumulus* and *alto-stratus,* lighter in value than *stratus* clouds.

The high clouds, called *cirrus,* are a white filmy variety of clouds inclined to be thin, wispy or feathery, formed of ice crystals. The *cirro-stratus* are fairly uniform widespread layers of haze, lying in sheets high in the air, and darker than the *cirrus*. The *cirro-cumulus* form small white rounded masses usually in regular groups forming a "mackerel" sky.

Of course it is not necessary to use the Latin names for the different types of clouds. However, you do want to know what they look like so that you can paint them.

Clouds high in the sky are more brilliant than those lower down and can be painted in sweeping curves, while those near the horizon are grayer and lie closer together in horizontal lines and, of course, look decidedly smaller. Just above the horizon the clouds usually fade into the previously mentioned layer of vapor and are no longer visible as individual clouds.

FIGURE 46 CLOUD SHADOWS

Before starting to paint a sky I carefully study the design of the clouds and try to pick a pattern that will go with the rest of the picture — one that will carry the lines of interest in the lower areas of the picture right up through the sky.

Although clouds give the appearance of standing still, they are actually always in motion, so it is necessary, if you like a certain effect, to draw them as rapidly as possible before they change. When you have a cloud pattern that you like, stick to it and don't keep trying to find something better, because you may not find it and you will only waste valuable time that could be spent working on the rest of the picture.

When drawing clouds, try to see them in simple masses of light and shade. I try to keep quite a little warmth in the shadows of the overhead clouds. Those farther away and nearer the horizon should be grayer and cooler, since as we have seen, distance grays and cools all colors. A bright orange dory, for instance, is a much more brilliant color when it is nearby than when it is halfway across the harbor.

Don't forget, while painting the sky, to watch its effect on the rest of the picture. You can see what happens when clouds cast

shadows over parts of the scene, then you can make up your mind where you want your brilliant lights and what portions of your picture should be in shadow (Fig. 45). Of course, the sky color reflects down over the whole picture.

We have all watched the rapid change that takes place in a harbor when a blue sky becomes overcast. The blue in the water of the harbor completely vanishes and is replaced by a leaden expanse that has picked up the color of the sky. I think the toughest thing about outdoor painting is to capture some such effect before it changes completely.

I remember starting a fascinating fog scene one morning at Gloucester, on Cape Ann. A fisherman was loading gear in a lobster boat

FIGURE 47 WINTER TWILIGHT *Collection, Dr. John Houlihan*

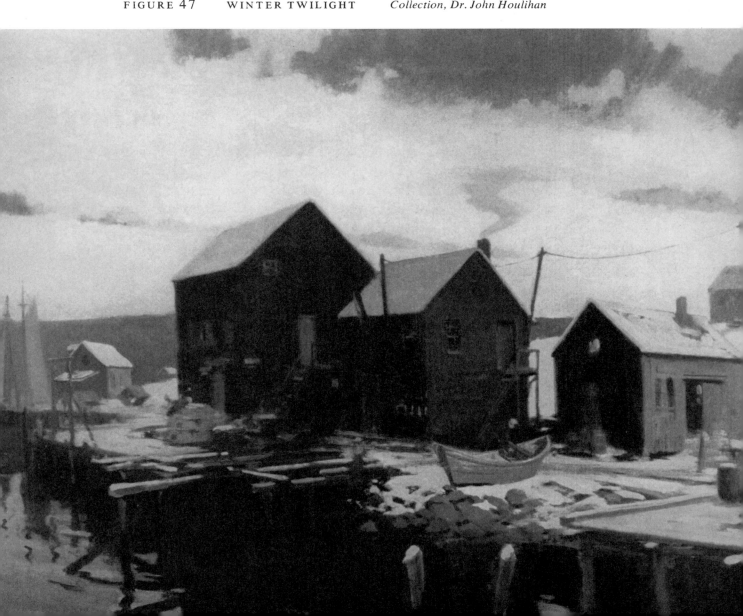

tied up to a float with a little of the wharf seen in the distance. It looked mysterious and picturesque with a soft diffused down light on it, but by the time I had drawn it in, the fog had disappeared and I was left with a most unpleasant background, complete with gas tanks and brand new shiny-looking warehouses. The mystery was gone. There remained only a flat sunlight effect that came from behind me, obliterating all shadows. While I was deciding what to do, the lobsterman started up his motor and happily chugged away for some distant point outside the harbor leaving behind a discouraged artist who felt like giving up the whole thing and turning to flower painting!

When painting clouds, use a large brush and paint as freely and loosely as possible with many soft edges. Paint quite a lot of sky with vertical brush strokes instead of horizontal ones. In this way you paint across the horizontal clouds and achieve a looser, more artistic effect, one that helps to suggest the domed look of the sky. When painting clouds, try to keep their shadows as simple as possible, with hardly any detail in them. The light areas should be simple with the high lights toward the center, that is, well inside the light areas of the clouds. You can suggest modeling, in the different masses, by the degree of sharpness or softness you give to their edges. Clouds have much softer edges than you would think possible. You can paint a whole sky with only one or two sharp touches having all the rest of the edges simply melt into each other. That is why masts or buildings with comparatively sharp edges are so effective when silhouetted against the soft, mushy clouds behind them.

If you are undecided whether an edge is sharp or soft, just squint at it for a moment with eyes half closed. The soft edges, when studied in this manner, will disappear. As a rule, the greater the contrast between two adjoining masses the sharper the edges; with less contrast, the softer the edges. If you think that the edge of a cloud is quite sharp, compare it to the mast or smokestack of a boat and you will see that it is really fairly soft.

The easiest skies to paint are generally light skies with dark clouds (Fig. 46), or fairly dark skies with white clouds (Fig. 33).

When trying to decide how light or how dark to paint the sky, compare it with the strongest lights or the darkest darks in your picture (Fig. 47). You will find that skies are usually fairly light in value unless they are dark storm clouds or you are painting a night scene.

8: *Selecting the Subject*

BEFORE I START OUT FOR A DAY'S PAINTING, I carefully check my equipment to be sure that I haven't forgotten something of vital importance such as zinc white or my easel. It is horrible to discover, when you are ready to paint, that something is missing. Once I got all the way to the Virgin Islands before I discovered that I had left my brushes behind!

When you get to the waterfront, look the scene over carefully and select a view that interests you. If it appeals to you and looks as though it would make a good picture, paint it. Don't waste time trying to find something better because you may not find it.

It is better to avoid a complicated subject such as the panorama of an entire harbor. Choose a simpler subject — just a boat and part of a wharf or some old tumbled-down fishhouses. Next, look at the scene from several different directions to be sure that you have the angle that will give the most pleasing arrangement of the areas of light and shade. Then note the direction of the light and of the sun. You can thus anticipate the changing light and later you won't have to make any drastic changes in your pattern of light and shade. It also helps to have a schedule of the tides so that you can tell whether they are rising or falling and can accordingly make your plans.

When you have decided on your subject matter, the angle from which you wish to paint it and the anticipated changes in light and shade, you might then study it through your view finder to decide just what portion of the scene to include in your picture (Fig. 48). There is so much to see outdoors anyway, it is always necessary to eliminate the unimportant and concentrate on the important elements of your scene.

FIGURE 48 GOLDEN HARBOR

Before starting to draw in your picture, it always helps to make one or two small pencil sketches of the scene to be sure that you have a good dark and light design for your painting (Fig. 49). Remember that you have only one real center of interest in your picture. It can be a group of boats tied up at a wharf or a mass of old buildings, but it must dominate the scene and first attract the eye. Everything else in the picture must be subordinated to it or lead the eye toward that center of interest.

Don't let the fact that a scene has already been painted by other artists bother you. Practically everything interesting has been painted many times but probably not the way you will paint it (Fig. 50). Often a commonplace subject can be made immensely interesting by the way you place it on your canvas or by painting it from a slightly different

58

angle. After all, the same scene looks a little different to everyone as no two individuals see alike, and your picture should reflect this difference.

Every artist should always carry a small drawing pad and form the habit of making quick sketches of interesting scenes. These sketches are of the greatest value when painting away from the shore. You will find that you can remember things much better if you take time to make a sketch of them. Even a hasty sketch will help you recall a scene more vividly.

I have occasionally tried taking a photograph of something that interested me instead of sketching it. This seems to work out very

FIGURE 49

FIGURE 50

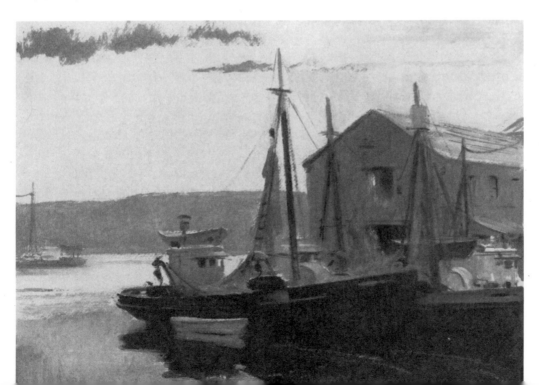

well for a great many artists, but not for me. When I look at the photograph I have taken of a scene, I cannot figure out what the different blobs of light and shade are supposed to be. The fact that I am the world's worst photographer may have something to do with this lack of success. I do know that many artists, particularly illustrators, depend on photography to a great extent and seem to have very successful results.

When you have decided on the scene you want to paint, you will sometimes find it makes a perfect composition. In that case you are in luck and will have nothing to worry about except painting what you see in front of you. Occasionally, however, you will find the composition is not ideal, and you will have to eliminate a few objectionable objects or move things around a little to make a more decorative composition. This is perfectly all right. Since an artist isn't a camera he should use his own judgment and good taste in deciding what to include and what to eliminate in his picture.

When painting outdoors, be sure to have your canvas in shadow, because it is impossible to see color correctly if the sun is shining directly on your picture. You will discover that direct sunlight gives a nice, warm glow over everything, and a sketch that looks warm and brilliant in the sun will look cold and gray when you look at it back in the studio. Bright sunlight on a canvas is rather blinding to look at and certainly doesn't help your eyes. I generally carry two canvases of the same size and put one in back of the other on my easel so that the sun doesn't shine through the canvas on which I am working. Since I usually work on one canvas in the morning and the other one in the afternoon, it is very convenient to have them both right at hand when I need them.

After you have selected your subjects and are ready to start the picture, be sure that you are in a comfortable spot in which to work. If you stand, have something smooth to stand on; if you like to paint sitting down, be sure that you have a good place for your stool and easel. Nothing can be more disconcerting than to step back into a crevice in the rocks or have the rotten planking of a wharf give way unexpectedly and deposit you in the water. Besides, if you are uncomfortable when you are painting, it may show in your picture. It is difficult to create an effect of carefree abandon in your painting if you are balanced uncomfortably on one foot or teetering on a stool that feels as though it were ready to capsize at any moment.

60

9: *Painting the Picture*

HAVING DECIDED ON YOUR COMPOSITION and arranged yourself and your equipment to your satisfaction, you can start to draw in the picture.

With a little light blue paint and a lot of medium draw in outline the shape of all the important masses of light and shade. This defines the pattern — the framework — of the entire picture. It must not be altered except to refine or modify minor details.

Then paint the sky rather thinly but in the right value and color. As I have mentioned previously, the sky sets the color and key of the whole picture. Sky color will reflect down into the rest of the composition, particularly the top planes of objects in shadow. As you paint the sky, you also paint its reflection in the water, taking care to study the variations of color and value of the water from the distant horizon to the extreme foreground. You will remember that these gradations were described in considerable detail in Chapter 6, *Painting Harbors* (Fig. 51).

Now lay in the dark masses of your painting, starting with the center of interest and continuing throughout the picture (Fig. 52). Try to approximate the correct value and color of these dark areas and also their general shape and proportions. If you find that the silhouettes of the different objects aren't exactly correct, don't worry, because you can change them as you go along. This direct method of painting was described in Chapter 4, *Direct Painting with Oils.* You can add details, modify values and strengthen your color where needed until you feel that the picture is finished (Fig. 53). Try not to overwork your picture, because it is very easy to spoil a vigorous start by fussing with it too much. It is better to leave your painting looking

FIGURE 51*

FIGURE 52*

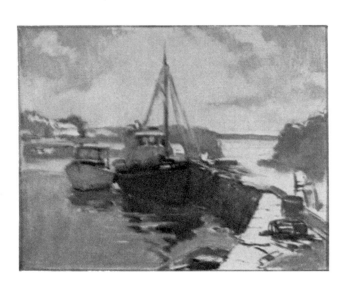

a little unfinished rather than to try to polish it up completely.

A great many years of my youth were devoted to magazine illustrating, and I still have a desire to give everything I paint a high commercial finish. My gentle wife always says that all my pictures are masterpieces at the end of the first half-hour, then they begin to deteriorate slowly in direct proportion to the time I spend on them. I

* See color insert between pages 32 and 33.

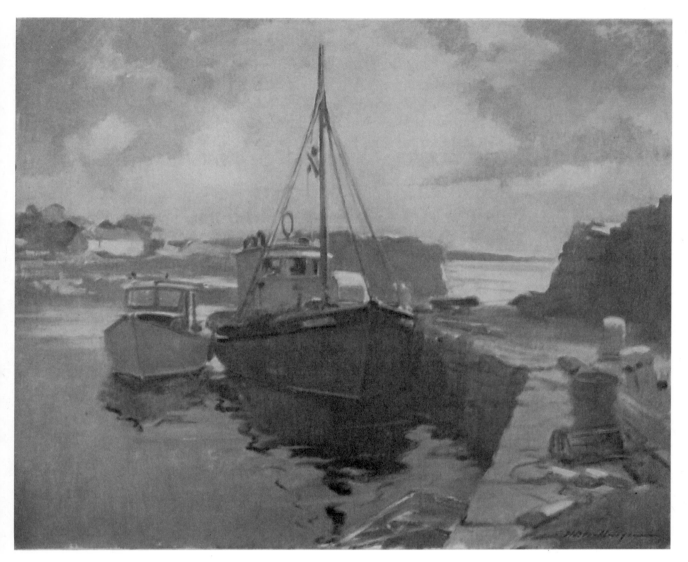

FIGURE 53* THE GREEN BOAT

have indignantly denied this, but there may just possibly be an element of truth in her remarks.

When I am laying in a picture, I can hardly wait to get the entire canvas covered. I think we all feel the same way about looking at large, blank expanses of canvas. So, until you get some tone over the entire area, you can't tell exactly how the composition will look. I al-

* See color insert between pages 32 and 33.

ways paint rather thinly at first, since it is a good idea not to pile up surplus paint that might get in the way later on. When you have determined the proper shade and color of the different areas, you can paint as heavily as you wish.

Whether you paint heavily or thinly is simply a matter of your own personal taste. Of course you want to put enough paint on your canvas so that it won't be too thin or transparent looking, but you don't have to put on big lumps of paint unless you like it that way. I generally paint my shadows fairly thin but add more paint to the light spots. Many artists load on their paint with great abandon, and their paintings look strong and dramatic; others use hardly more than a thin stain of paint. I believe that you can strike a happy medium between these two methods. Certainly, whether a canvas succeeds or fails isn't dependent upon the amount of paint that you put on it. So when you are out painting, just do what comes naturally and you will probably be all right.

It is a good idea when you are painting around tidal water to concentrate your attention on the boats, because they are subject to the action of the tide and are liable to get the wanderlust at any moment. It is important to get them before they can get away from you. When I paint a boat at a wharf with the tide rising, I try to place it a little higher in relation to the wharf than it is at that moment. In this way you anticipate the rising tide and can work on it for quite a while without too noticeable a change in the relative positions of the boat and the wharf. You can do the same with a falling tide — just draw the boat a little lower in relation to the wharf. It isn't necessary to finish the boats completely first, but don't neglect them. I try to work all over the picture after the first lay-in. In this way I think of the picture as a whole and don't overwork any particular area. I suggest that you try to keep your shadows as flat and simple as possible. Don't try to see too much detail in shadows — it will add nothing to the effectiveness of your picture. Keep the lights rather simple also, just concentrating your details on the half tones between them.

Try not to clutter up your picture with unimportant details; it is much better to suggest them rather than to draw them all in. I never could understand why anyone would want to go in for the so-called Magic Realism, with every detail in the entire picture painfully recorded. I don't think that it is fair to the photographers to try to usurp their field.

One advantage of working in big, simple masses with a minimum of detail is that you can work much faster and have a better chance of completing your painting before you lose your original enthusiasm.

There are a few points about color that I would like to mention here. Your strongest color should be in your center of interest and in the foreground. If you are doing a sunlight scene you will find a lot of warm color reflected from your sunlit areas into the adjacent shadows. In fact, you can use warmer colors in these spots than in the light areas. In painting sunlight you have to be careful not to get it too warm. It is only the late afternoon sun that has the pinky orange glow to it. If you paint midday sun with that much warmth in it, you will find that it has an eggy look.

Generally, keep as much warmth as possible in your shadows; this will give them depth. Any horizontal surfaces in the shadow that are open to the sky will pick up some of the cool color from the sky. For instance, the shadow of a dory on a sandy beach will be cool wherever the sky can reflect down into the shadow, but under the side of the dory, where the light from the sky can't penetrate, the shadow will be quite warm.

Working outdoors in the full light of day you can slightly intensify the color in your picture since it will look a little cooler and grayer in the half-light indoors.

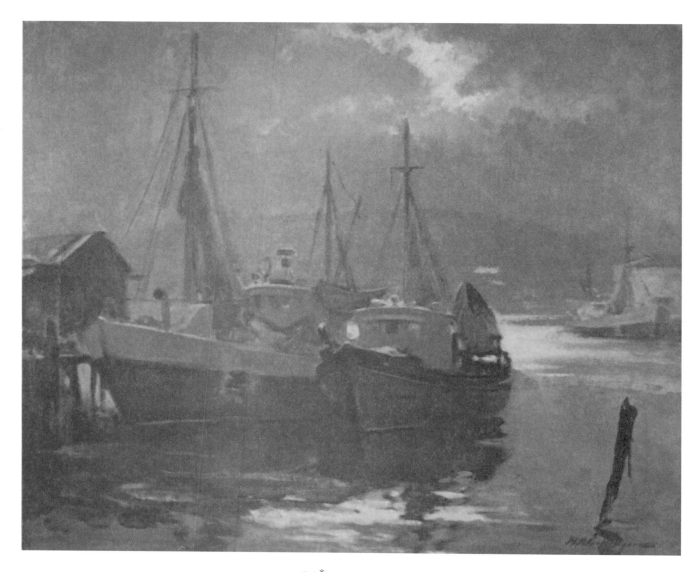

FIGURE 54* MOONLIT HARBOR

* See color insert between pages 32 and 33.

10: *The Harbor by Night and Day*

HARBOR PICTURES CAN BE PAINTED in a great variety of light effects and in many moods. In fact, it is an ever-changing panorama that can be serene and lovely as well as harsh and ominous, depending on the atmosphere of the moment.

Moonlight scenes are always mysterious and beautiful, particularly harbor scenes. It is possible to suggest so much with so little detail. Unfortunately it has to be done from memory, but I think that if you start your picture as soon as possible after viewing the moonlit harbor you will still have a pretty good mental impression of the scene the next day.

Moonlight is cooler and much weaker than sunlight; as a result the shadows are darker and simpler. Light spots have little detail in them and shadows practically none. You can see the big division of light and shade, but that is about all. While moonlight is cooler than sunlight, I try to avoid painting everything blue or green, because there is warmth in the shadows as well as throughout the entire picture. Many artists seem to think that a moonlight scene is simply a daytime picture painted blue. This is far from the case, as you will observe when you study moonlight and see how it really looks.

An effective way to paint a moonlit harbor is to use a back lighting with the moonlight reflecting on the water and boats or on the shacks silhouetted against the light (Fig. 54). If you don't show the moon itself, you can suggest its location just above the top of the picture either by showing its light on clouds or by a glow of light on the sky extending a little way down into the picture. When you don't show the source of light, you can paint reflected light in your picture blue if you wish. On the other hand, when you do show the moon itself,

the rest of the lights have to be toned down, to make the moon look sufficiently bright so that you have very little sparkle left for the rest of the picture. The only time that you can safely show the moon is when there is still some light from the setting sun to provide the general lighting for the entire picture. In this case the moon won't be bright enough to be the source of light. This kind of picture can be breath-takingly beautiful if it is well done. It is, however, really more of a sunset than a moonlight effect.

While sunset and twilight scenes are sometimes considered too sweet and sentimental to paint, I like them and I think almost everyone else does too. There isn't anything wrong with this type of picture. It is just the cheap and gaudy way that they have been painted by so many buckeye artists over the years that has rather dimmed their popularity in the upper art circles.

A sunset has to be done chiefly from memory since it changes every minute and hardly ever lasts long enough for you to make more than a few hasty notes of the color and shape of the more important clouds. To see the most brilliant color you usually look into a sunset. Therefore you will have a scene with a back lighting, with the sky and its reflections in the water forming your light pattern and everything else forming part of your dark pattern. It is better not to show the sun itself but to have it behind a cloud or just below the horizon with its brilliant lights reflected on the clouds and the still water of the harbor. You will thus find that a lot of the warmth of the sky will be reflected down into the whole foreground, particularly on the horizontal planes.

Your painting of a sunset can never be as brilliant as the real sunset because you can only approximate the value of light itself with the limited range of oil paints. You will find that it is difficult to get sufficient strength of color into the sky and at the same time to get the sky light enough. To do this you will have to use a good deal of white with your color, particularly with the reds, which are rather low-keyed colors. It is probably just as well that we can't reproduce all this brilliance on our canvas, since nature produces some rip-roaring effects that, in a picture, would look like the gaudiest kind of calendar art.

There is a lovely tranquil feeling about a twilight scene that has a great appeal for me. I like the simple pattern of light and shade that you see before dark. The sky and its reflections in the water are the

68

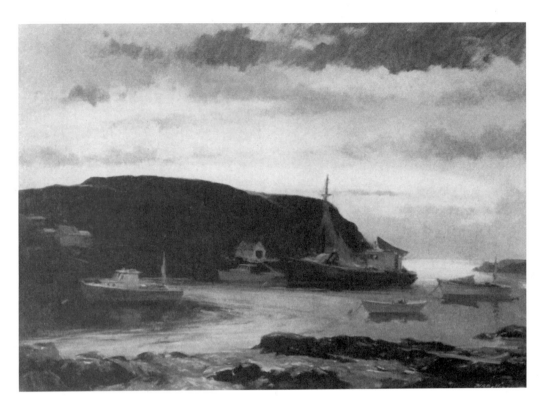

FIGURE 55 MONHEGAN HARBOR

light pattern, and everything else is part of a darker silhouette. The whole picture could be painted almost entirely in two tones of light and shade with very few colors and only a little detail in the center of interest or in the foreground (Fig. 55).

You can frequently use an analogous color scheme, that is, just a few related warm colors or a cool scheme with cool colors. It is fun to go out at sunset to some favorite spot along the waterfront and there study the scene before you as it changes from twilight to dusk. If the light permits, make a simple pencil sketch of the pattern of light and shade, jotting down the general color of the large areas in the picture. In your studio the next day, try painting the scene as you remember it with the aid of your sketch and penciled notes. You can often produce an extremely convincing picture with the real spirit of twilight in it.

The harbor is fascinating in fog or rain and certainly interesting to paint under these conditions. A fog scene has mystery and can

FIGURE 56 MONHEGAN FOG

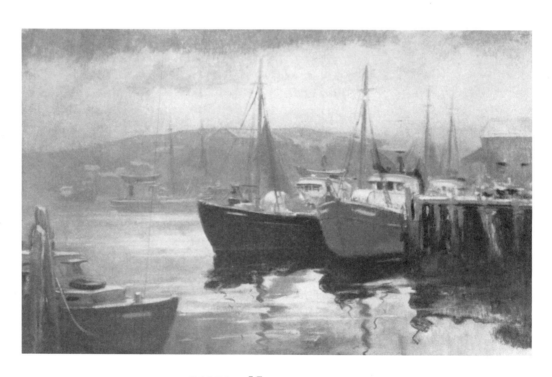

FIGURE 57 SHOWERS

70

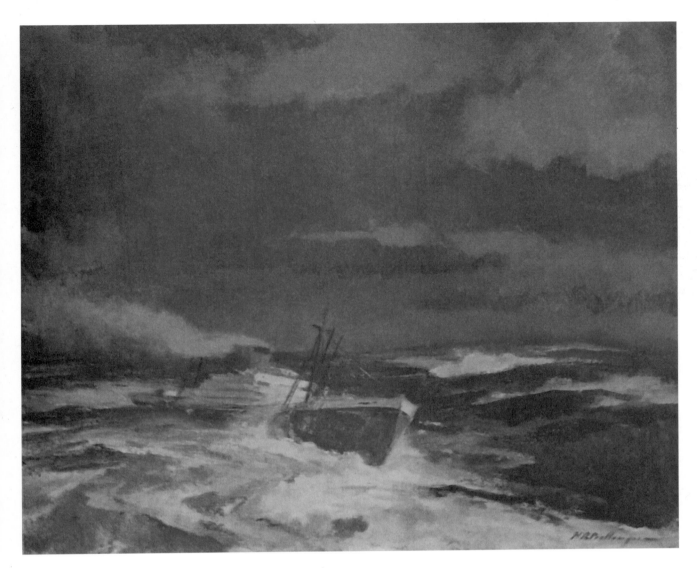

FIGURE 58* HEAVY SEAS

make a very effective picture, especially with a little warm light break-
ing through in the foreground or hitting the center of interest. In a
fog scene you cannot see the horizon line; it is lost. In your painting
you have an opportunity to make a striking pattern of your foreground
and middle distance against a simple light gray background (Fig. 56).

* See color insert between pages 32 and 33.

You can paint the foreground in full value but, owing to the density of the atmosphere, objects should be rapidly grayed up the farther away they are in the picture. At a short distance they should only be visible as simple spots of light and shade with practically no detail. Still farther away they should vanish completely.

A fog scene can be painted in tones of warm gray with a strong color in the foreground and center of interest. There will be a diffused down light on everything in the picture which will emphasize the horizontal top planes of objects in contrast to the darker upright planes. In painting a down light on a scene, it may help just to *think* of the light as a thin layer of snow on top of everything (Fig. 56).

A rainy day scene makes a good picture, although it isn't quite as pleasant to look at as a fog scene. You have the same down light on everything from the sky, but you also get reflections in all smooth, wet, horizontal surfaces of light and dark objects directly above them. The tops of objects look wetter and are lighter. There are also darker clouds in the sky with very soft lower edges where the rain is falling. The whole picture can be painted in a cool color scheme (Fig. 57).

A storm is always exciting and dramatic and can make a powerful picture (Fig. 58). It will probably have to be done from memory, because it is no cinch to try to paint outside in bad weather. I have known a few hardy marine painters who used to try to paint outside in a howling gale and I occasionally ventured out myself in my younger days, but now I am content to study the scene from as comfortable a spot as possible — usually from a cozy station wagon — and paint the picture when I return to the studio.

Storm scenes are often quite popular with some of our present-day juries of selection who will accept them for their shows and throw out some of the pictures of the more peaceful aspects of nature.

Possible picture buyers, on the other hand, may admire storm scenes, but they are more likely to buy a picture that is more tranquil — one that makes them feel happy when they look at it. So most artists paint two kinds of pictures — dark, gloomy ones that they hope the juries and art critics will like and pleasant, nostalgic scenes that are pleasant to look at and to live with which they hope will sell. Honestly, it's a great life!

11: *Ships at Sea and along the Coast*

BOATS, AS I HAVE MENTIONED PREVIOUSLY, can be divided roughly into two classes — the small ones that operate off a beach or in harbors and the larger seagoing ones. So far, in this book, when I have talked about harbors, I have been thinking of the smaller harbors along the coast that are filled with rowboats, outboards, regular powerboats, pleasure and fishing boats (Fig. 59). The waterfront scenery is on a small scale, usually with quaint old fishhouses and shacks scattered around just waiting to be put in a picture.

The larger harbors, however, are much more impressive, and everything is on a larger scale. There will be found large freighters, beautiful ocean liners, an occasional naval vessel looking sleek and gray, old, battered tramp steamers, as well as countless tugs, barges and powerboats. The wharfs are longer and in better repair, and the warehouses and other buildings on them enormous. Back of the wharfs the buildings of the city loom in an impressive sky line. There is an effect of movement and excitement in the scene in striking contrast to the peaceful quiet of the small harbor, which often looks half-deserted. Yet, there is the same smell of the sea, the gentle lap of the water against the piles and the cries of sea gulls that are typical of harbors everywhere. In rain or fog they appeal to your imagination, seem to be part of a different world, perhaps a simpler, pleasanter kind of life. If you love the sea, you can never forget it and will always be happiest when you get back to the coast and breathe the salty, fishy harbor air again.

Painting ships at sea is a different problem. Here you have to imagine the scene or use sketches or photographs that you have made while on an ocean voyage. This type of picture depends for its effec-

73

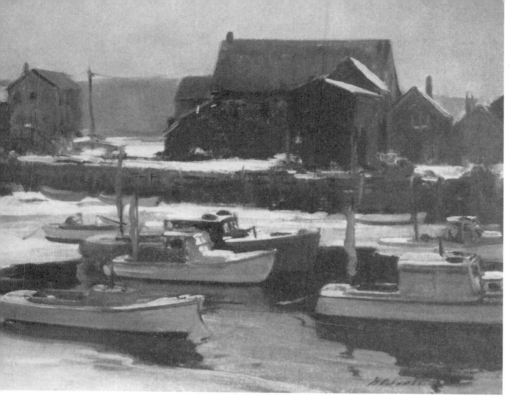

FIGURE 59 TIED UP

tiveness on the mood and light effect of the scene or on a dramatic
story involving the age-old struggle of men against the sea (Fig. 60).
Ships sailing at sea have more pictorial interest when something is
about to happen or is happening to them. Sinking ships, rescues, cast-
aways on rafts (Fig. 61), a ship struggling in heavy seas all make
more dramatic pictures.

FIGURE 60 MACKEREL BOATS
Collection, Mr. and Mrs. Roscoe C. Ingalls

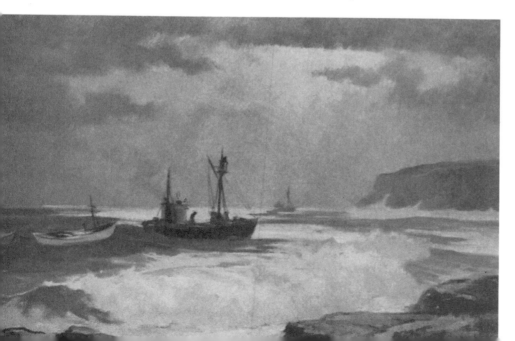

Nearer the coast you will have smaller vessels, small freighters, and fishing boats and can show a distant headland for added interest. Along the shore, wrecks and old hulks are ideal subjects for pictures (Fig. 62). I have always been fascinated by them and I am sure that everyone likes to explore an old hulk on a beach and wonder how she came to be wrecked and what happened to the crew.

Let us look at some of the small boats that you encounter in a harbor or along the beaches and then take a look at some of the larger seagoing ships. Dingies, skiffs, and dories are all rowboats, made for utility and service rather than for beauty. They are useful for short jaunts on the water when a powerboat isn't needed. Nowadays there are a great many outboard motorboats in use around the harbors. They get you places with speed and noise, and it is certainly easier to sit and ride than to have to do the rowing yourself.

Lobster boats are sturdy powerboats with a low cabin forward and a partially enclosed pilothouse and a large cockpit aft. Sometimes they

FIGURE 61 SURVIVAL

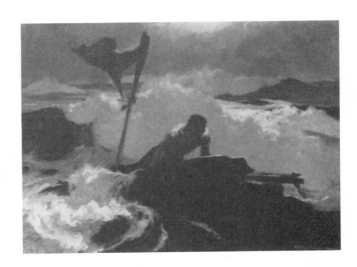

FIGURE 62 · DERELICTS

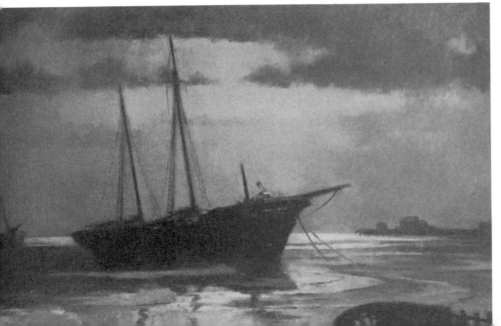

are even simpler, ordinary motorboats with a tarpaulin over the fore part of the cockpit which helps protect the helmsman from the weather (Fig. 63).

Fishing boats come in all sizes, from the small dragger with one hoist for nets to a large, powerful seagoing trawler that can spend weeks at sea and ride out any gale. There are all types of tugs, from small harbor tugs to large, powerful seagoing ones. Most tugs seem to be either in a hurry or to be towing several unwieldly barges behind them at a more decorous speed. There are countless freight and cargo vessels, from rusty old tramp steamers to fine, fast, modern freighters that compare favorably in comfort and style with the more *de luxe* ocean liners.

There is, in addition, every kind of small passenger-carrying motorboat and, of course, countless pleasure craft that vary in size from the tiniest class sailboat that will capsize at the drop of a hat to the plush, elegant yacht.

I have always wanted to own a small, sturdy boat in which I could cruise around for part of the year. So far there has been one slight obstacle to my acquiring the ideal craft; I have discovered, when talking about the kind of boat that I would like to own with my gentle wife, that her idea of the perfect boat is a nice, wide houseboat, preferably one with windowboxes filled with geraniums. This seems such a horrible idea to me that I guess I will have to pass up the joys of being a boat owner for awhile and content myself by looking at and painting them from a distance.

In the illustrations I have pictured a few of the more familiar types of boats often seen along the coast.

FIGURE 63 QUIET COVE

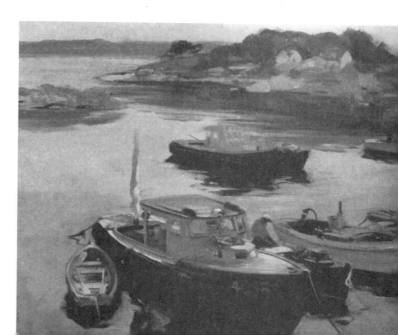

12: *Some Favorite Harbors*

IN RECENT YEARS I have lived mostly in New England, so quite a good deal of my harbor scenes are painted along the North Atlantic coast of the United States. For about four months of each year we live at Rockport, Massachusetts, where we hold classes and painting demonstrations and operate the Ballinger Gallery. In my free time, I often paint around Rockport and the nearby harbors on Cape Ann.

Rockport has a tiny harbor, just large enough for lobster boats and small yachts, and it does have the famous red fishhouse on the stone pier that has been painted so many times that it is widely known as Motif No. 1 (Fig. 64). If ever you are approaching insolvency and the bill collector is catching up with you, just paint a picture of this motif; it is as good as money in the bank, for you can practically always sell it. The only trouble is that after you have done it a number of times, it is extremely hard to think up different angles from which to paint, and you get so bored that you begin to wish you never had to see the picturesque old shack.

Gloucester, on the other hand, is a busy seaport town with fishing boats coming in daily to supply the fish-processing plants around the harbor (Fig. 65). There are dozens of boats to paint and many picturesque old wharfs and warehouses around the shore.

Some of the nearby harbors — Marblehead, Pigeon Cove, Lanesville and Annisquam — are picturesque but are mainly harbors for yachts or lobster boats (Fig. 66).

When I go up to Monhegan Island, off the coast of Maine, each spring to paint the surf along its forbidding seaward side, I usually end up by painting its small harbor with the towering bulk of Man-

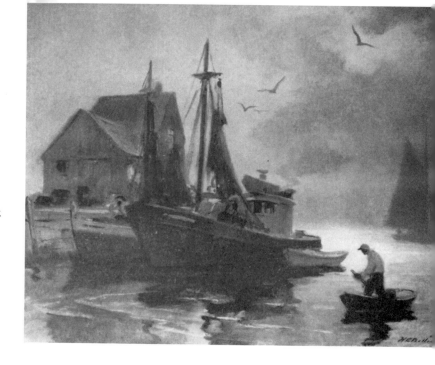

FIGURE 64

MOTIF NUMBER ONE

nana, the adjoining island across the harbor. It makes a dramatic picture, particularly if painted in the afternoon with the sun behind it silhouetting it against the sky (Fig. 67).

New York City has a fine harbor, and you can find paintable subjects on either side of Manhattan Island. Both the Hudson and the East River views are good, and the view coming up the bay, with

FIGURE 65 HOME PORT

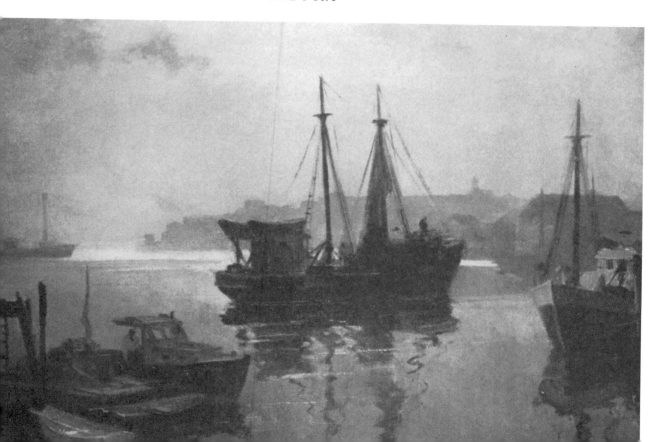

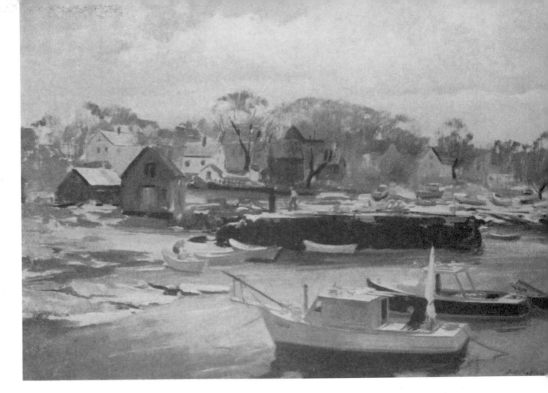

FIGURE 66 SPRING AT LANE'S COVE

the Battery in the background, is magnificent (Fig. 68).

Of course, San Francisco has a wonderful harbor and is exciting to paint, particularly the view of the Golden Gate at sunset or when the fog is coming in, turning the bay into a ghostly, mysterious no man's land (Fig. 69).

In South America the harbor of Rio de Janeiro is a spectacular sight but it is difficult to paint.

FIGURE 67 ISLAND HARBOR

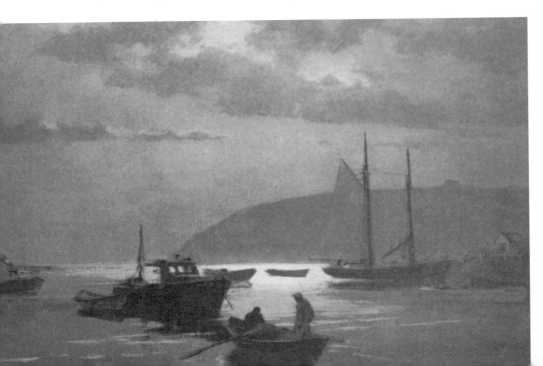

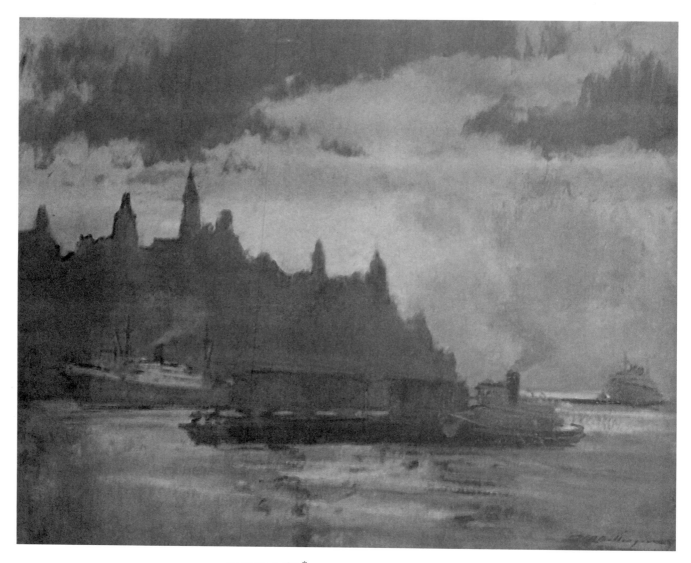

FIGURE 68 * MANHATTAN SKYLINE

I remember a few spots in Europe with pleasure — several channel ports in England and Concarneau and Quimper in Brittany. I myself still prefer the smaller, more intimate harbors although the large ones are certainly impressive.

In the Caribbean I enjoy painting in the Virgin Islands, particularly the beautiful harbor of Charlotte Amalie at St. Thomas (Fig. 70) or Christiansted at St. Croix. One thing about painting near the equator is that there is practically no tide and your boats stay put a lot better than they do in the North, where they go up and down like elevators during the course of a day.

* See color insert between pages 32 and 33.

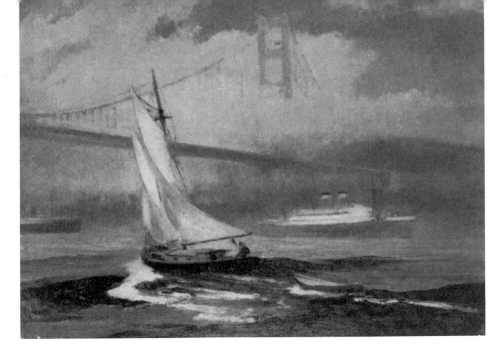

FIGURE 69 GOLDEN GATE

In the Caribbean and remote parts of the tropics, you can still see sailing craft that are working boats. Some are fishing boats while others carry cargo between the different islands providing a pleasant but cramped home for their numerous crew members when away from home. I have watched them coming and going in the small harbor of Christiansted on the island of St. Croix. The captains handle their

FIGURE 70 CHARLOTTE AMALIE

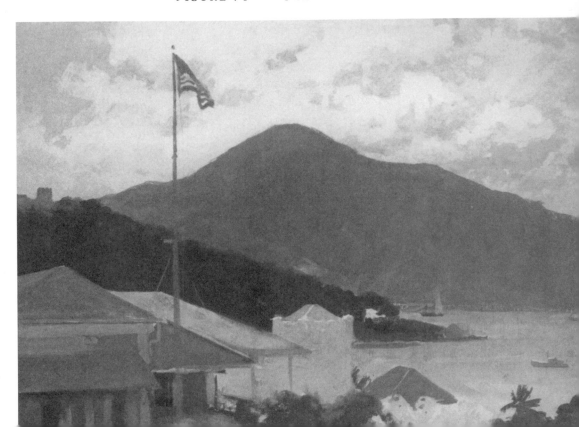

sturdy craft with the precision and grace of any yachtsman. The boats are small sloops and schooners with rather blunt-looking hulls that are very solidly built. The sloops have their single masts nearer the middle of the boat than do our boats up north. Their mainsails have a long boom that projects well past the stern. This probably adds to the maneuverability of the craft and allows room at the bow for a couple of good-sized jibs. Their decks are filled with the usual assortment of gear lying around in seeming confusion. On deck there is often a fascinating collection of livestock — chickens, cows, dogs and goats — that are quite at home aboard ship. One time on a boat from Trinidad I saw a fat and very contented black pig. When I inquired if he were carried along for food, the captain said indignantly, "Certainly not!" The pig was the mascot and friend and they would not think of eating him. It sounded like a pleasant life for me; I almost felt like trading places with that pet pig!

At the stern of the larger boats there are often, on deck, two long box-shaped bunks with sliding doors for the captain and mate. When these boats are in port, a large tarpaulin stretched over the boom at the stern provides shade from the sun. Some of the larger boats have auxiliary power which is sometimes used when coming in or going out of the harbor, but most of the smaller ones are solely dependent on their sails for locomotion.

There are usually a number of American yachts in these waters and they are inclined to be trimmer and more gracefully built. However, I believe that if you were at sea in bad weather you would be much safer in one of the native boats than in one of the beautiful but fragile modern yachts.

Sailing vessels make such a fine decorative spot in a picture I wish there were more around. Sails, when silhouetted against the sky, have fine pictorial possibilities and are equally effective in full light against a dark headland or sky.

When painting a harbor scene I always add a sailboat if I possibly can. The sails are such a pleasant contrast to the skeleton-like appearance of the masts and rigging of the powerboats.

Occasionally you will see a small sail on some of the draggers and lobster boats. These are simply to steady the boat at sea and are of little help in propelling it. However, in a picture, they do help to fill up the empty spaces around the masts. Nets hauled up to the masthead to dry also have good pictorial possibilities.

13: *On the Spot Painting and Studio Work*

MOST SERIOUS ARTISTS TODAY want to paint a picture that is more than a competent reproduction of a particular place or incident. They want to paint a more personal interpretation of the scene, one that has mood and feeling.

It may seem strange but more fine pictures have been painted in the studio than have been painted directly from nature. When you are away from a scene you remember its mood, perhaps the dramatic lighting or color harmony and the general composition of the picture. In the studio you can paint it as you remember it and, free from distraction, you can concentrate on the important elements of the picture, leaving out all the unessentials (Fig. 71). You can be more imaginative and creative in your color harmony and in your composition. However, in order to paint in this way you must be thoroughly familiar with the appearance of those things you want to include in your painting. The only way to gain this familiarity is to sketch and paint outdoors, directly from nature (Fig. 72).

When you are outside painting — perhaps boats in a harbor — it is a good plan to paint the scene exactly as it looks to you. You want to know as much about it as possible, and the best way to gain this knowledge is to try to paint exactly what you see. A painter should do as much outdoor work as possible to keep him from getting stale. I think most of us find that, after painting in the studio all winter, we can hardly wait to get out and start painting the real thing again. You can get into some bad painting habits if you stay away too long from nature which, after all, should be your main source of inspiration.

In the case of the amateur or part-time painter whose opportunity

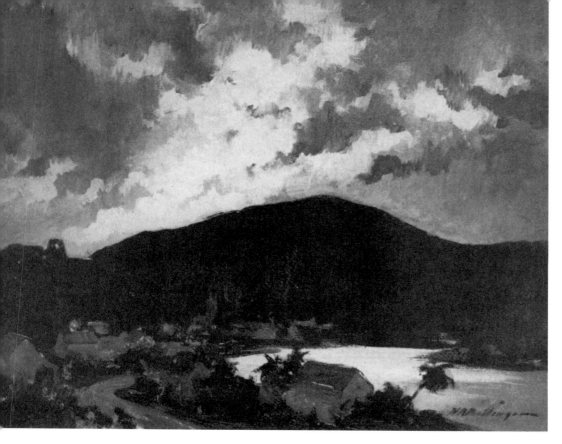

FIGURE 71 CARIBBEAN HARBOR

to paint is limited, it may be necessary to do more indoor work. But whenever you have any spare time on week ends, after work and on holidays, try to get outside and draw and paint as much as possible. You will find it rewarding in many ways. In my own case I find that while I spend considerable time painting in my studio, my outdoor sketches are invaluable reference material (Fig. 73). And I know that I would get into an awful rut if I stopped all outdoor work.

FIGURE 72

TOLL OF THE SEA

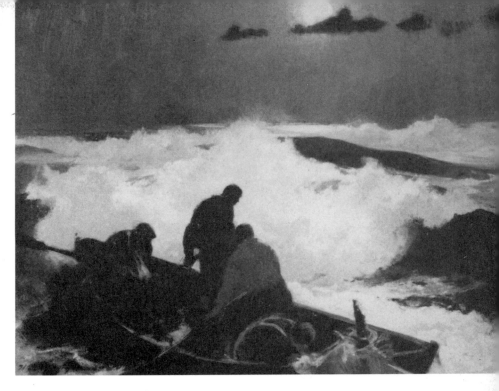

FIGURE 73 THE SURVIVORS

Collection, New Britain Art Museum

When working in the studio, you can achieve some very interesting results by using an arbitrary color scheme. Some of the most effective pictures are those painted with a limited color plan. For example, you can paint a monochromatic harmony using different values and tints of a single color. When I use one color throughout a picture, I sometimes add a bright accent of a closely related color. In *The Outer Reef* I painted the whole picture in tones of blue-green except for the light strip of sky just above the horizon. There I used a pale lemon yellow (Fig. 74). A warm brown can also be used advantageously with a little touch of pale blue somewhere.

My favorite picture is one using an analogous color scheme, that is, several closely related colors. A picture painted in a warm scheme — warm green, pale yellow and perhaps an orangey brown — can be a beautiful color arrangement. One painted in cool colors — purples, blues and greens — is equally satisfying. I'm never happier than when I am painting some familiar scene in an arbitrary scheme. It gives a fresh and different look and almost always produces a mood that

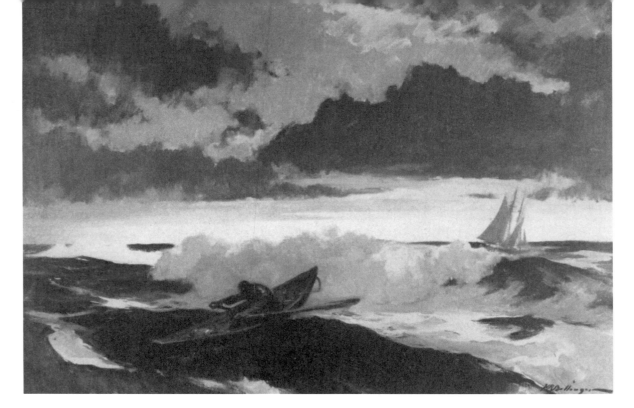

FIGURE 74 THE OUTER REEF

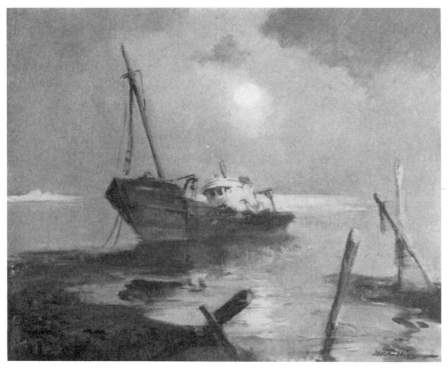

FIGURE 75 PALE MOON *Collection, Mr. and Mrs. G. A. Firestone*

86

could never be conveyed by painting the subject in its more familiar aspects (Fig. 75).

In addition to painting a more personal and perhaps more imaginative picture in the studio, you will find that your outdoor work frequently requires adding some finishing touches in the studio. Often you will need to make minor changes and readjustments either in color or in composition, for after you have worked steadily on a picture for a considerable time your eyes are tired and you cannot always see your mistakes. However, when you see it later on with a fresh eye in the studio, you are able to catch your mistakes and correct them.

The only danger in working on these outdoor pictures in the studio is that you may *overwork* them. I know that I have trouble in this respect. I often see so many things in my outdoor sketch that I don't like that I repaint the whole picture in the studio creating an entirely different picture. So, try to repair only the more obvious mistakes and leave the rest of the picture alone. A painting to be good does not have to be a perfect picture. Sometimes a few sloppy touches add effectiveness to the whole composition. Anyway, let me repeat, try not to lose the vigor and freshness of your outdoor picture by polishing it too much in the studio.

One reason it is possible to be more creative while working in the studio is that there are fewer distractions. The weather doesn't bother you and the "friendly" bystanders with their fascinating comments aren't around. Some of my students say that they feel self-conscious, when painting outside, to have people stop and watch them. I think that the only thing to do is to relax and remember that the bystander probably can't draw or paint as well as you can.

I remember one cold, nasty winter day when I was painting a snow scene near my home in New Hartford, Connecticut. I was down in Maple Hollow trying to paint a view looking up a ravine. Every little while it would start to sleet or a puff of wind would blow my easel over. I tied the easel to a fence post and kept mopping the snow off the palette. My feet were wet; I was cold; I began to suspect that I was getting pneumonia. While I struggled with the elements and my picture, one of my neighbors came along. He was a sturdy old boy who looked hale and hearty — also warm and dry. He stopped and silently watched me paint for quite a while; then, when he finally decided to move on, he turned and said, "Well, it helps pass the time, don't it?"

14: *Practice Subjects*

IN THIS CHAPTER ten different compositions of boats or harbor scenes are presented for your use in practice painting. Each painting has a simple two-toned arrangement of light and dark and you can work out your own gradations of tone and color harmony.

I have suggested a possible treatment for each picture, but you will want to try out your own ideas on some of the compositions.

You will find that you can produce a variety of paintings by simply changing the color scheme, the direction of light or the mood of the paintings. It is a fine idea to use your own imagination as much as possible, for this is the way to paint a more creative and original type of picture.

Composition No. 1. We have a sunset with a brilliant sky reflected in the quiet water of the harbor. The dark pattern consists of the dragger, with its reflections in the water, in the center; the boats tied up to the wharf on the left; the distant hill and the lobster boat on the right. You can paint the sky and the reflecting water different shades of orange, yellow and pink; the clouds warm grays with just a suggestion of blue or green near the top; the various darks could be warm browns, greens and purples. Let the water in the foreground be a darker shade of brownish green. Keep a good bit of white in the light parts of the sky and in its reflection in the water. Don't show the sun itself; it lies hidden behind the hill.

Composition No. 2. Here is a fog scene with a simple down light on the float, on the men and the boats in the left foreground. The schooner in the distance will be just a flat gray silhouette with very little detail. Paint the sky and water a warm gray, a little lighter directly overhead in the center, a little darker and greener in the lower

88

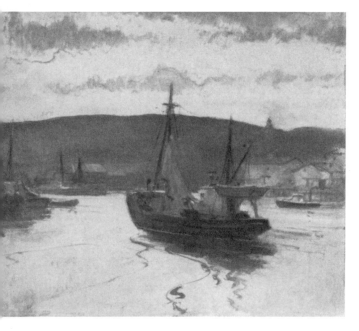

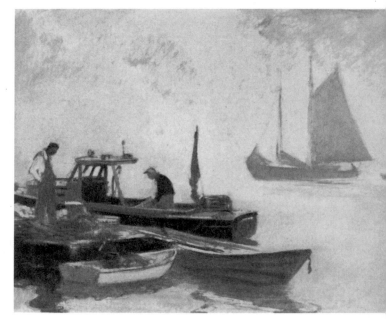

COMPOSITION 1 COMPOSITION 2

right-hand corner. The lobster boat is a dark brownish green. The skiff next to the float is light gray with a red gasoline can in it. The dory next to it is orange-red. The man in the boat is wearing a red shirt. The deck and roof of the lobster boat should be orangy yellow. The man on the dock is wearing yellow overalls. The reflections in the water are the brownish greens. A cool down light is cast over the entire composition.

Composition No. 3. We have a marine scene in the moonlight. Sky and water are a warm purplish blue with a little green. Both the dark schooner and reflections are dark purplish brown. The distant shore and boat are bluish purple. The piles in the right foreground are brownish purple. Clouds near the moon are rather warm tan. The light of the moon on the clouds and on the water is a pale yellow with lots of white in it. There is just a touch of warmer yellow in the reflections of the moonlight in the water at the bottom of the picture.

Composition No. 4. The afternoon light is coming from the right side, hitting the man on the wharf and his pal in the seine boat. The bow of the trawler, the seine boat and part of the wharf are in sun-

light. The dory, the side of the big boat, the wharf in the foreground and the old building at the right are in shadow. The whole sky and its reflections in the water can be painted a warm, grayed-up pinkish tan. The hull of the dragger, the reflections in the water and the shadows under the dock should all be warm brownish green. The hull of the seine boat is warm white. The dock is light warm tan and the shadows are blue-gray and brown.

Use orange for the trim and inside of the seine boat, the masts of the dragger and the dory moored alongside. You might put the customary red shirt on the man in the seine boat.

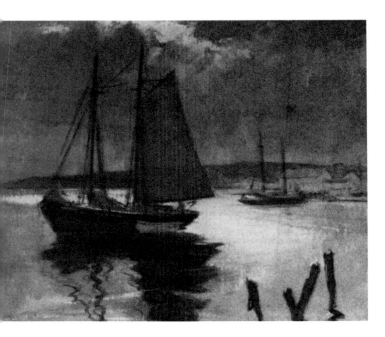

COMPOSITION 3

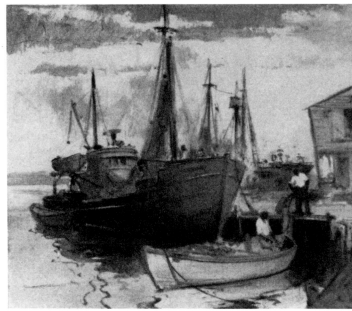

COMPOSITION 4

90

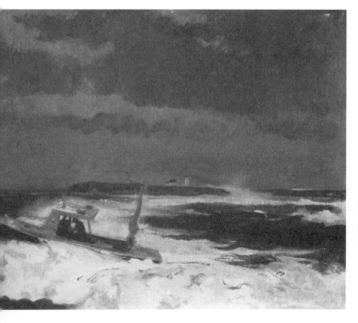

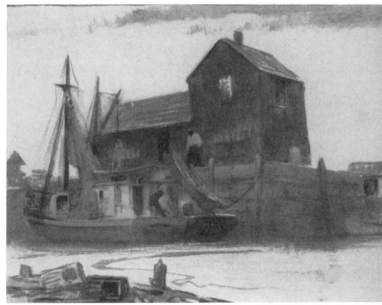

COMPOSITION 5 COMPOSITION 6

Composition No. 5. In the picture of the lobster boat running before the storm, paint everything in dark blue-greens with a few touches of orange on the roof of the cabin and the deck of the lobster boat. The foreground foam can have just a touch of pale yellowish tan in the lighter portions while the distant cresting waves would be a pale toned-down gray-green. Be sure to keep more gray-green in the sea than in the sky, although it is a good idea to use the same color in both areas.

Composition No. 6. In this twilight view of Motif No. 1, try to paint the whole picture in two values. The light sky and its reflection in the water would be a pale orange. The buildings, draggers and dark reflections in the water would be brown, blue and green, with just a touch of grayed-up red in the motif itself. The draggers would probably have green hulls and pale greenish brown deckhouses. The dory could be dull orange, also a couple of the lobster buoys in the left foreground. I took the liberty of putting some fishing gear, a lobster pot and the markers on the end of T-Wharf in the foreground. I never saw any there, but let's pretend that someone left them there momentarily. I think we need a little interest in the foreground, don't you?

Composition No. 7. In this picture of sailboats tacking up the coast, you can paint the nearby boat and the surrounding water dark blue-green, while the distant water could be a pale green and the distant shore a blue-gray. The sails in the distance could be in a warm light. The sky could be pale orange-green. The clouds would be blue-gray with a touch of orange in the light. You might use touches of orange-red when painting the deck, roof of the cabin and the foreground. A colored shirt would look well on the helmsman.

Composition No. 8. In the rainy day scene, paint the dark clouds blue-green and brown and the distant headland blue-gray. Paint the light parts of the sky and water pale tannish green, the buildings on the wharf brownish gray, the dark reflections under the wharf brownish green, the hull of the larger lobster boat tied to the dock dark blue, the one in the lower right-hand corner dark brownish green. The furled sail of the nearby boat, as well as the tarpaulin over the bow of the boat at the dock, could be tan. Be sure to have the roofs and all top surfaces very light gray in order to make them look as though they were reflecting the sky and were wet and shiny.

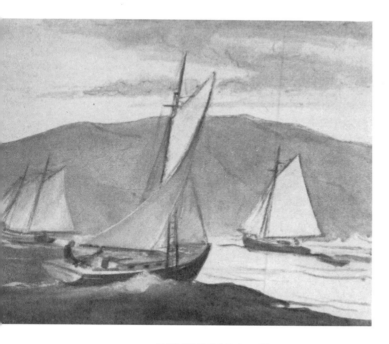

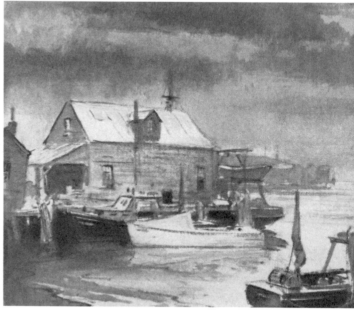

COMPOSITION 7

COMPOSITION 8

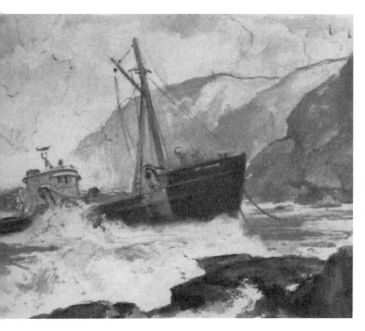

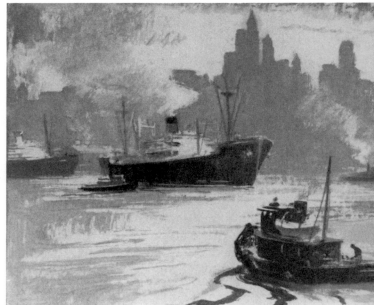

COMPOSITION 9

COMPOSITION 10

Composition No. 9. In the picture of the wrecked dragger, you can use very much the same color scheme that you used in Composition No. 5, of the storm. Paint the sky in tones of blue and brown, the sea in blue-green and the dragger and foreground rocks in brownish green. You might use just a little pale blue-green in the foam of the wave in the foreground, a few orange-brown touches on the rusty surface of the dragger and an accent or two of orange in the foreground rocks.

Composition No. 10. In this view of New York Harbor, paint the scene with a warm pinkish gray sky and water. Paint the tug in the right-hand corner a warm brown and its cabin and pilothouse orange-red. The hulls of the big freighter and passenger boat on the left can be warm brown and the superstructure light cream. The smokestacks on the freighter could be red with a dark band at the top. Pale tan-colored smoke can pour from the freighter's funnel. Keep the sky line of lower Manhattan a very pale, warm, bluish gray — a flat silhouette with no detail. This will suggest haze and fog in the distance and will be a lot easier than putting in every painful detail of the skyscrapers.

In Conclusion

AT THE RISK OF SEEMING TO BE REPETITIOUS I would like to restate briefly that the three important elements in a picture are composition, good drawing and color. If you wish to improve your own work, you should learn everything that you can about drawing, color and composition and should paint just as much as possible. After all, the only way that you can learn to paint is to work at it constantly.

Good drawing is the foundation of any picture and should never be neglected. I have spent my whole life attempting to learn to draw with more facility and accuracy and have never been entirely satisfied with the results. You can never draw too well, so try and improve your drawing by always carrying a sketch book with you wherever you go and by making brief sketches of everything that interests you. In other words, just try and draw everything everywhere. After all, when you are painting a picture you are constantly drawing with your brush, so you are really always drawing when you are painting.

Your color, too, will improve with practice and you will be able to get nicer color harmony in all your pictures. As you gain experience, you will learn what colors look well together and you will be able to use them with good taste.

Composition, or design, is the most important part of your picture, so always try to get the most effective design that you can in your painting. When you go to an exhibition, make a note of the dark and light pattern of any of the pictures that appeal to you. When outdoors study any interesting subject that meets your eye and see if you can figure out its basic design — its linear structure as well as its dark and light pattern. All this takes hard work and concentration but it

is worth the effort to be able to paint a fine picture — one that will please your family and startle your friends.

Originality is a great thing to strive for and I think it is a good idea to avoid imitating another artist's work, even if you like his style and know that his pictures are very saleable. An imitation is never as good as an original product. If you look at the work of all artists, either through reproductions or at exhibitions, I am sure that you will find a great many helpful ideas in their pictures without actually copying their work.

Without using involved technical language, I have tried to tell you as much as I can in this book about painting boats and harbors. It isn't a manual for the boat builder or the marine architect, but I hope that it is an instruction book that will help you over the initial hurdles when you are learning to paint these fascinating subjects.

If any of you folks are in Rockport, Massachusetts, in the summertime, I hope you will come to the Ballinger Gallery and tell me how you are making out painting boats and harbors. Until then, good-bye and good luck.

Index